MW00582688

Montana ICONS

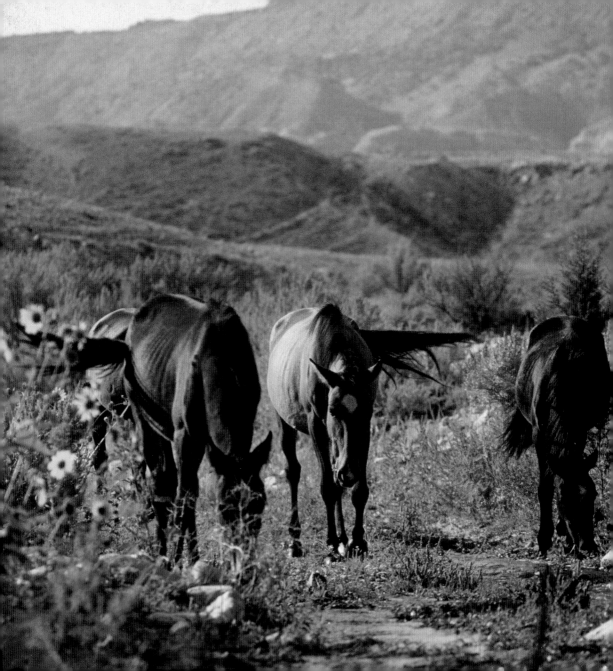

Montana
ICONS

50 CLASSIC SYMBOLS
OF THE TREASURE STATE

Bert Gildart

gpp®

Guilford, Connecticut

To buy books in quantity for corporate use
or incentives, call **(800) 962–0973**
or e-mail **premiums@GlobePequot.com.**

Photo on page 41 courtesy of the Library of Congress
All other photos by Bert Gildart

Text design/layout: Casey Shain
Project editor: Lauren Brancato

Library of Congress Cataloging-in-Publication Data is available on file.

ISBN 978-0-7627-7967-3

Printed in the United States of America

10 9 8 7 6 5 4 3 2 1

*For Janie, my wife, whose search for clarity
approaches the deeper meaning of the Navajo Prayer:
[Let us] Walk in Beauty.*

CONTENTS

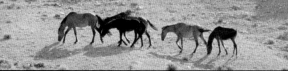

MONTANA—SO EASY ON THE MIND

Whoa there, partner! You are about to enter the nation's fourth-largest state, variously known as the Big Sky, the Treasure State, and the Last Best Place, all of which suggest that Montana is a land through which you must not hurry.

Here's where Custer was defeated, the Lewis and Clark Expedition spent over one-third of its time, songwriter Jimmy Buffet found the sleazy saloon that inspired a number of his songs, the rodeo replaces football as a spectator sport, and cowboy poetry is an art form.

Here, too, is where Margaret Bourke White photographed one of FDR's "make-work" projects, the Fort Peck dam, providing the cover for *Life* magazine's premier 1936 issue.

Though the state has certainly grown since those days, it contains but a million people, and still has places obscure enough to hide the likes of Theodore Kaczynski (the Unabomber) for years—even from the FBI. Happily, it is still big enough to serve as a home for both the grizzly bear and the wolf, though likely you'll never see these critters 'less you go looking.

In broad brush strokes, Montana has ten national forests, more than twenty national wildlife refuges, and is home to Glacier National Park, which has been declared a world heritage park.

What's more, the state administers its own special areas, from caves and badlands to one of the largest prehistoric bison jumps in America.

Derived from a Spanish word that means "mountain," Montana fits its name to a tee. In the western one-third, the Rockies dominate, the tallest of these mountains forming a chain known as the Continental Divide. This group of towering peaks directs the flow of water to three different drainages: the Atlantic, the Pacific, and Hudson Bay.

Though the remaining two-thirds of the state is high prairie, seldom is one far from the sight of mountains. Here these outliers assume romantic names: Bear Paws, Castles, Crazies, Snowies, Sweet Grass Hills, Beartooths, Long Pine, and Little Rockies. Drifting in a canoe by many of these mountains can almost bring time to a halt.

Because of such great topographical variation, the state has experienced incredible extremes in temperatures, recording a high of 117°F and a low of −70°F. Montana even claims the most extreme temperature change on record in the United States: On January 15, 1972, temperatures rose 103 degrees, from −54°F to 49°F. The warm chinook winds that created this change are renowned along the east slopes of the Rockies. Back in the 1880s, artist Charlie Russell made his debut with

his drawing of a starving cow, its ribs showing and head drooping, being circled by hungry wolves. He entitled his now-famous picture *Waiting for a Chinook.*

Despite the harsh weather, the land has long been inhabited by indigenous peoples. Rock art in Pictograph Cave six miles south of Billings dates back 2,100 years and largely represents the work of wandering bands that followed the buffalo. Today's Indian nations now primarily reside on one of the state's seven reservations.

The Indians' desire to learn about Christianity prompted the state's first permanent settlement, and on September 24, 1841, Father DeSmet arrived in present-day Stevensville and established the St. Mary Mission. Six years later the American Fur Company established Fort Benton, which marked the farthest point to which steamboats could navigate the Missouri River. It quickly grew into a major trading center, eventually earning the reputation as "the birthplace of Montana."

In 1862 gold was discovered on Grasshopper Creek in Bannack, and on May 26, 1864, Montana became a United States territory. On November 8, 1889, Montana was designated the nation's forty-first state.

Subsequent to the discovery of gold, settlements developed, but these mining camps had no effective law enforcement—and sometimes their governments were corrupt. To remedy this, vigilante committees sometimes took the law into their own hands—literally.

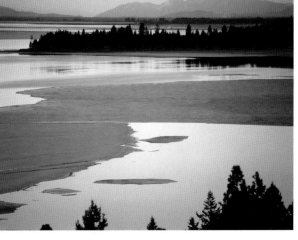

Mining remains one of the state's biggest industries, right alongside ranching. In 1866 Nelson Story drove a thousand longhorn cattle from Texas to Montana, which started the Montana cattle industry in earnest, and engendered a culture that today romanticizes the cowboy life through some mighty tall tales told by a new breed of poet. Their stories will make you linger in Montana, but so will all its saloons, rivers, glorious mountains, rodeos, and powwows. So, slow down and take time to absorb the philosophy of these independent groups, and maybe even try to make some of it your own.

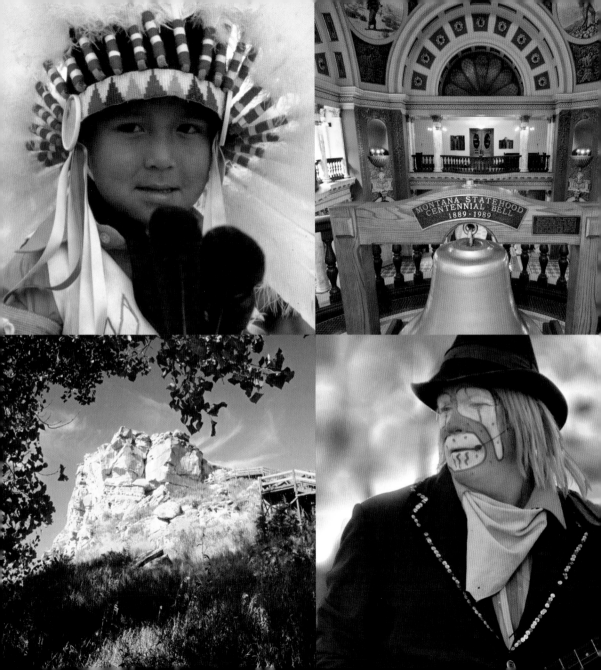

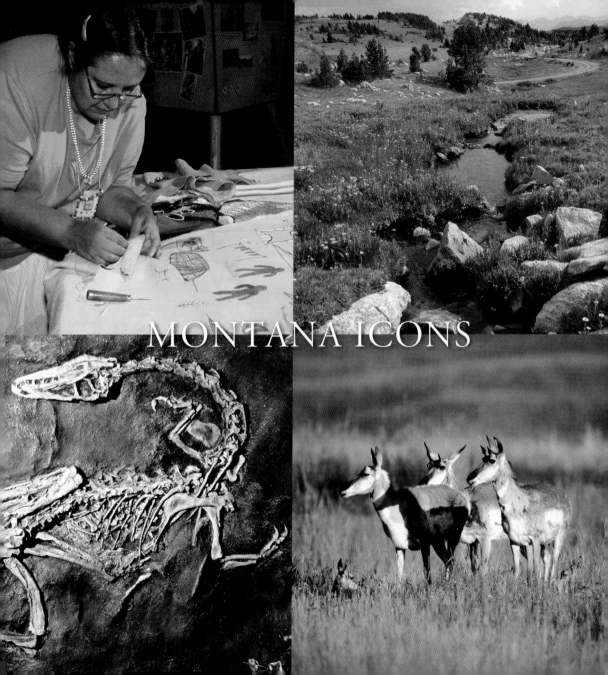

MONTANA ICONS

COWBOY POETRY

Wally McRae, who once portrayed the Marlboro man, began by suggesting to the audience that the Big Sky produces more first-rate cowboy poets than any other state, in part, "because of the isolation."

Ranchwoman Gwen Peterson, who helped found Montana's first Cowboy Poetry Gathering, agreed. From there, a roundtable discussion ensued with bronc busters, teachers, farriers, and ranchwomen contributing thoughts about other probable origins of—and appropriate themes for—cowboy (and cowgirl) poetry. That was twenty years ago and, essentially, the format remains the same.

Cowboy poetry originated when night riders followed the cattle, riding round herds singin' songs to calm the beasts, thinkin' perhaps of stories to tell their compadres. However, only a few of their stories ever got written down, and it wasn't until the early 1980s—when Montana ethnologist Jim Griffth tracked down a number of aspiring cowboy poets—that these artists began to put pencil to paper. The response couldn't really be corralled without an appropriate venue, so in 1984 a small town in

Though little in life is for sure / Three things on the ranch will endure / Sticky mud to your thighs / Ugly bugs every size / And a steady supply of manure.
—Cowgirl poet Gwen Petersen

eastern Montana hosted the state's first gathering of cowboy poets. The event has grown and has only gotten better.

Rancher Wally McRae, a subsequent recipient of the National Heritage Award, scored big with his tale of "*Reincarnation.*" The funky poem pokes fun at life and death, focusing on a cowboy who has died and is on his "transformation ride." He is laid in a coffin, which soon "melts down." Posies sprout and reap nourishment from the cowboy's corpse. Above ground, a horse reaps nourishment from the posies. But wait, the horse can't use all of the flowers' nourishment. Some "passes through," providing McCrae with fodder for his conclusion: "And [I] come away concludin': 'Slim, You ain't changed, all that much.'"

As the weekend continues, more poets recite, and there ain't no question about it: Not all will appreciate—or understand—the materials that flow from these hoss- and cow-hardened poets. But for those who have lived in a raw country, these verses soften a hard life with humor and sometimes with a bit of philosophy that adds depth and understanding to one's life.

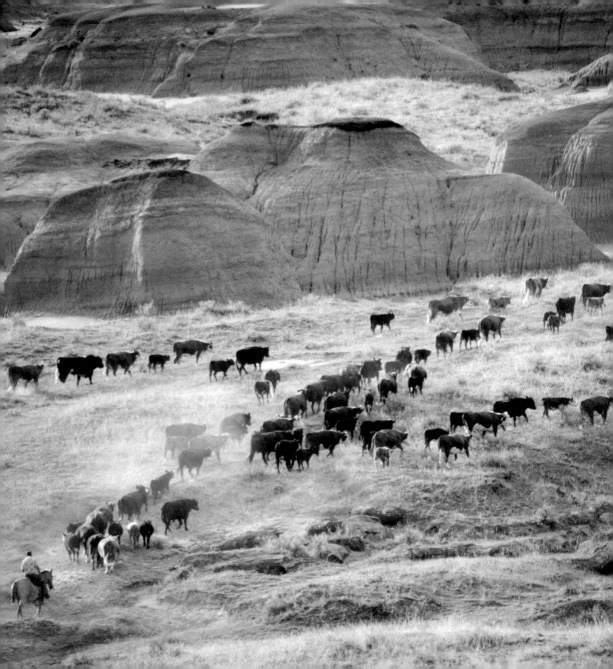

MISSOURI RIVER

On a warm, clear autumn day near Virgelle, Montana, several companions and I pushed canoes into the cold and murky waters of the Missouri River. Although frost had formed the previous night, and autumn winds had long since scattered and shifted leaves from cottonwood trees, winter seemed light years away.

Sometime after midnight a breeze began to stir, and at dawn we awoke to an entirely different setting. The wind had completely subsided, but the air was cold—five above, according to Dave's pocket thermometer. And now, small flakes of snow were beginning to fall.

The frigid environment was unlike any I'd ever before experienced. Ice edged out from the shore and as we paddled it also built up on our paddles. But changes in scenery, color, and weather are one of the many lures of the great Missouri River. In only twenty-four hours this rugged country can range from sublime to fickle to capricious. Hundreds of artists have been lured here to capture its quiet beauties on canvas.

Launch a canoe along the Missouri at either Fort Benton or Virgelle, and you'll drift back to a time when life was much less complex.

Great geological forces began the groundwork for impressive formations along the Missouri—places like LaBarge Rock, the Citadel, Steamboat Rock, and scores of others named by romantic and iconoclastic dreamers. Still, it is climatic nuances that created their final forms. Wind, rain, sleet, and snow have sculpted—one grain at a time—the raw geological materials into tabletop rocks, castles, and parapets.

Weather, of course, also has affected human travel along this waterway. In the late 1800s, ice sank the steamboat *Grey Eagle,* hail influenced Lewis and Clark, and hot weather beat down on the vast herds of bison. Weather changes have also influenced me, luring me back to this river on more than a dozen different occasions. It has created an area of vast intrigue where an individual can still remain carefree.

And so we paddled on, fascinated by the fact that the Missouri remains one of America's most majestic and remote rivers—a fact that should never be altered.

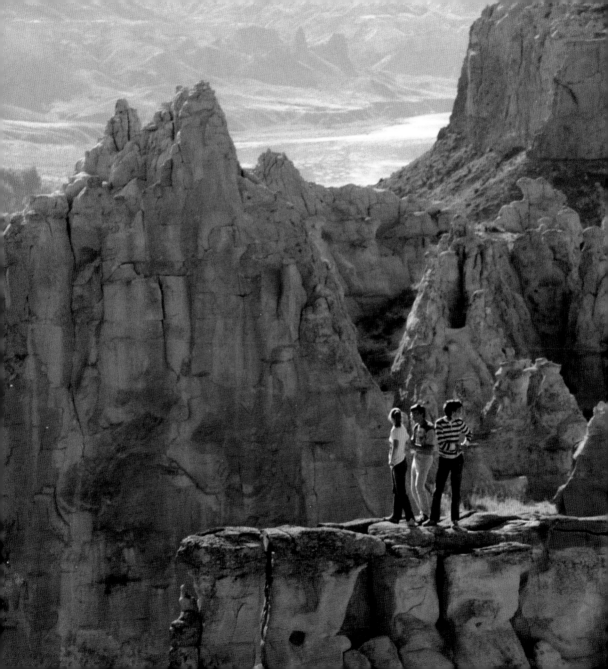

FORT PECK DAM

When you drive along a gigantic embankment twenty miles south of Glasgow, Montana, it is difficult to realize that this enormous hill, known as Fort Peck Dam, is the world's second largest earth-filled impoundment. Built in the 1930s, the dam was constructed as part of President Franklin Roosevelt's New Deal as a major project of the Works Progress Administration.

Perspectives unfold the moment you drop from the crest and coast into the Downstream Campground. Situated as it is in view of two huge but quiet generator towers, like most such sites it has electricity. It also offers views of downriver features, not the least of which is the Missouri River itself, essentially unchanged from the days when first explored in 1803. Here, as the Lewis and Clark Expedition poled its boats upstream, members saw grizzly bears and moose, though they were yet hundreds of miles from the Rocky Mountains.

Of course, the upstream or "lake" side is different, having been vastly altered. In fact, the length of the huge reservoir's shoreline exceeds the California coastline, and is all backed up by the

Fort Peck Dam is located in the northeastern part of the state, just south of Glasgow.

world's largest hydrologically filled dam. No question about it: The best way to take advantage of Fort Peck's many exciting features is to drag out your bike and ride to the Fort Peck Interpretive Center and Museum.

Though the gargantuan dinosaur replicas initially grab your attention, the bulk of the center is devoted to the "dam years." Construction attracted ten thousand out-of-work men and another forty thousand family members who took up residence in New Deal, McCone City, Roosevelt, or one of the area's other eighteen shanty towns. The expansive visitor center actually contains life-size replicas of some of the buildings, and it maintains a permanent display of Margaret Bourke White's photography, whose dramatic 1936 image of the dam provided *Life* magazine with its very first cover. Back then hard work satisfied many, but today it is the fishing on the reservoir, the nearby Charles M. Russell Wildlife Refuge, the old theater with its classy performances, the dinosaurs, and the rough and rowdy history of Fort Peck that combine to keep many mighty "dam" happy.

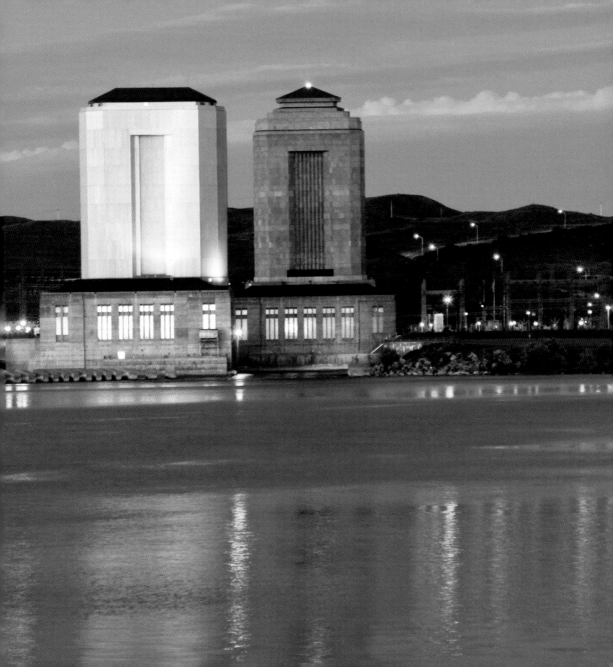

CHARLES M. RUSSELL WILDLIFE REFUGE

The stage is the Charles M. Russell Wildlife Refuge, and each night from the end of September through the first week of October, the curtain goes up at the Slippery Ann Wildlife Viewing Area on hundreds of elk. Each evening an estimated three hundred elk materialize from stands of cottonwood trees, and then edge closer and closer until viewers have front-row seats to one of the nation's greatest wildlife spectacles.

The performance begins at around 5:30 p.m., but before you see the elk, you can hear their famous bugling. Bull elk create the music by tilting back their heads and emitting a sound that begins on a low note, then progresses up the scale. It ends with a guttural "Ugh, ugh." Hearing one is impressive, but when dozens of bulls create the sound simultaneously, it blows your mind.

The purpose of the bugling—which is followed by aggressive gestures in which they use their antlers to blow up the dirt, "murder" small trees, or actually engage other bulls in battle—is to help each bull establish a territory.

Here, in a space each bull must

For more information on the Crown Jewel of the refuge system, see www .fws.gov/cmr/ Frequently AskedQuestions .htm.

mentally define, he guards his developing harem, and woe be to any interloper, particularly to "the welterweights," or to one whose spread of antlers is inferior, that enters this space. Presumably the genetically superior bull emerges victorious and it is he who passes on his genes.

We watched the display for about three hours and saw bulls whose antlers were represented by bulls fitting all the various descriptive nomenclature. We could see royals, imperials and monarchs, meaning we were seeing huge six-, seven-, and eight-point Goliaths.

Dramas such as this should be set on a stage of magnificence, and the landscape here provides it. Encompassing about 1,100,000 acres, the Charles M. Russell National Wildlife Refuge contains the entire Fort Peck Lake and runs along the Missouri River for 125 miles east of Fort Peck Dam. Lewis and Clark saw it first and described the area in glowing terms. The refuge was set aside in 1936 by President Roosevelt, and today some call it the crown jewel of the National Wildlife Refuge System.

Few would disagree.

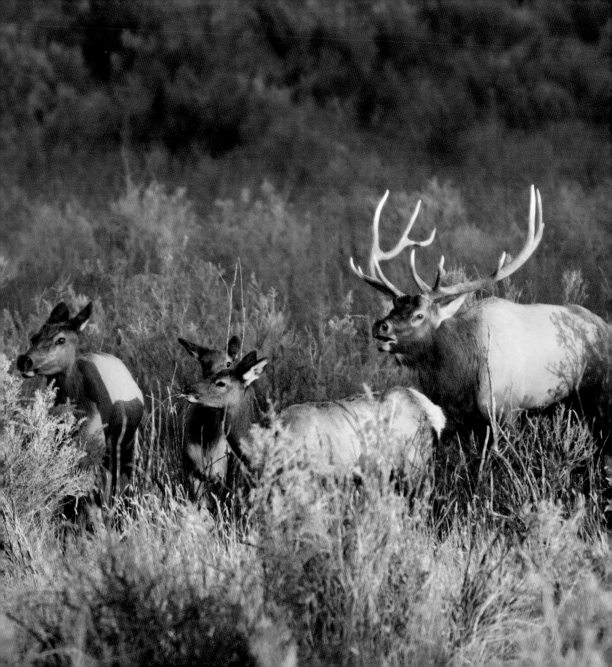

REMOTE SCHOOLS

At 8:30 a.m. each school day, a young woman emerged from a log cabin and walked a short distance to a small wooden building. At 8:45 a.m. she picked up an old bell, whose sound could be heard for over a hundred yards. Moments later, elementary-age children would emerge from nearby homes.

The scene may not seem much different from ones occurring at rural schools around America, but this particular school was unique. Before the children outgrew the small facility, it had the distinction of being the most remote school in the "lower forty-eight." Appropriately it was called the "Faranuf School," because it was almost "far enough" from everything. To the south the now empty building is flanked by Fort Peck Reservoir, while to the north it is hemmed in by rolling breaks that taper off into a vast sprawling plain.

The area's inhabitants consisted of only the Burkes and their hired help. In all, they had five children, just enough to qualify for assistance, bringing in a certified grade school teacher, who remained until the children reached high school, at which time they boarded in Glasgow.

Although the number of one-room schools has decreased markedly in recent decades, Montana still has the highest number of them in the United States.

When I interviewed Don and Julie Burke back in 1980, they said teachers who came here probably needed a little time to themselves. "Some people," said Julie, "may just need a year of isolation—a year to themselves to collect their thoughts. "And," said Julie, "they certainly get that here."

But students of such remote schools certainly benefit, and in way that may seem unusual for a system with such limited resources. According to Montana's Office of Public Instruction, rural students in Montana do well on standardized tests, better than their urban counterparts. For Montana's rural students that is important, as the state has more one-room schools than any other US state, between eighty-five and one hundred, depending on circumstances.

Nevertheless, schools come and go, for children age and grow. Faranuf no longer exists, but others currently function, such as the elementary schools at Lennep, Gold Creek, and Spring Creek. Some serve communal functions in that they are magnets for an exchange of ideas among all community members, certainly another aspect of education.

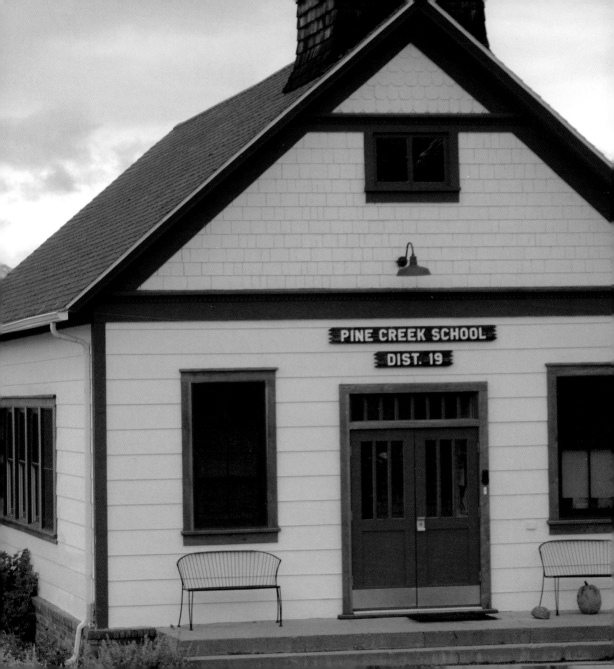

PELICAN ISLAND

On the high plains of eastern Montana, there is a lonely lake that surrounds a very special island. For more than half of every year, the island is covered by blowing and drifting snow, and its only visitor may be a lone coyote that has crossed the winter ice. Finding no mice, it soon trots off.

In April, warm winds sweep across the plains. The ice melts, and soon the island is surrounded by such a huge lake that no coyote could ever reach it. Separated from the prairie mainland, the island seems completely uninviting. It is then that hundreds of huge white birds wing their way through the vast prairie skies.

The birds are white pelicans, and they have flown two thousand miles north to reach this unique island so perfect for raising their young: It is flat, surrounded by a large body of water, and treeless, so as to make it easy to take off and land. In the United States fewer than a couple of dozen such places remain, and one is at Bowdoin National Wildlife Refuge near Malta. Here over a thousand pelicans crowd together and

Pelicans in Montana? Yup— including at Bowdoin National Wildlife Refuge near Malta, where thousands congregate each summer.

spend the busiest four months of their year.

In the weeks after their arrival, the pelicans lay eggs and then for thirty days share the task of incubating with their mates. When the young break free of their ovoid encasements, adult groups fly to likely feeding spots, splash down, and begin herding fish toward shore. Quickly they dip their heads, then swish their long beaks forward, eventually collecting hundreds of small squirming fish in their iconic pouches from which developing chicks can feed.

The young soon double their weight and simultaneously begin testing their black-tipped wings. About mid-August, the birds grow restless, and one morning members of the flock lift toward the rising sun. They circle higher until they are well above the tiny island. Moving behind their leaders the flock heads south, ignorant of dangers that lie ahead. Then, in typical pelican fashion, they flap and then soar, leaving behind the safety of their tiny treeless sanctuary, also known as Pelican Island.

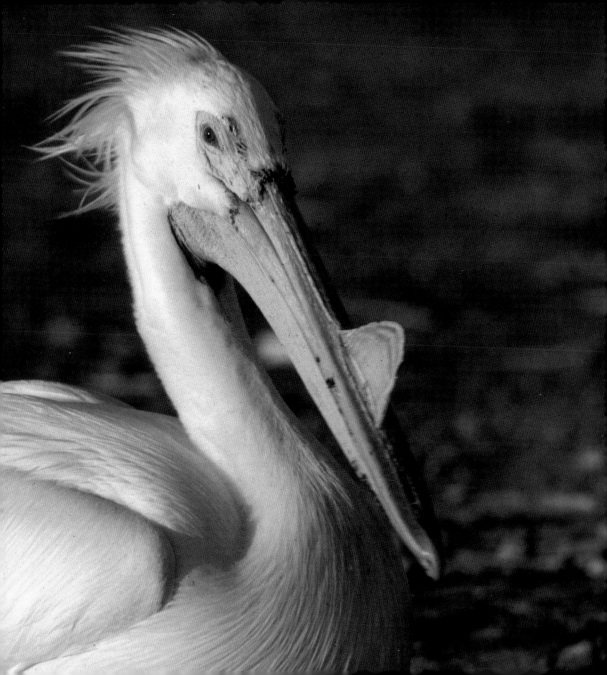

WOLF POINT RODEO

None of the riders were old, and first to charge into the arena was a young man—a kid, really—standing atop two horses which galloped all out.

The kid's brother followed, and his skills seemed even more impressive. Somehow, the rider eased down to the side of his saddle, using the strength of his leg muscles to prevent him from falling from the racing horse. Moments later he somehow pulled himself erect and back into the saddle—accomplishing all this in about a half run around the arena. These boys could ride! But what else might one expect at the Wolf Point Stampede, where the cowboy life is not only practiced but celebrated as a social way of life?

Later, the same older brother provided an incredible demonstration of trick roping, climaxed by actually encircling both himself and the horse into a loop. This really brought the announcer to his feet, who exclaimed, "Hey folks, let's hear it for the Thurston Gang."

The Wolf Point Wild Horse Stampede is not only one of the most popular rodeos in the United States, but also the oldest rodeo in Montana, and will celebrate its centennial in 2015.

But the evening was young, and this was just the prelude to wild bull and bronc riding and barrel racing, all capped off by the Wild Horse Stampede.

The Stampede begins with the release of thirty-three wild horses into the arena. Eleven teams consisting of three wild-eyed cowboys chase the horses while carrying saddles and swinging lassos. The object is to rope one of the horses, and control it enough so that one of the other team members can saddle it and then climb aboard. Horses, however, have a mind of their own, and one lassoed horse pulled a stubborn cowboy—clinging to the rope while on his stomach— the full length of the arena.

Meanwhile, members of one of the other teams managed to ride a saddled horse the designated length, and then control it sufficiently so that it would proceed to the judge's corner. It was a feat of strength and sinew, worthy of the Olympics, but confined to the wild prairies where the cowboy life is still practiced and heartily celebrated.

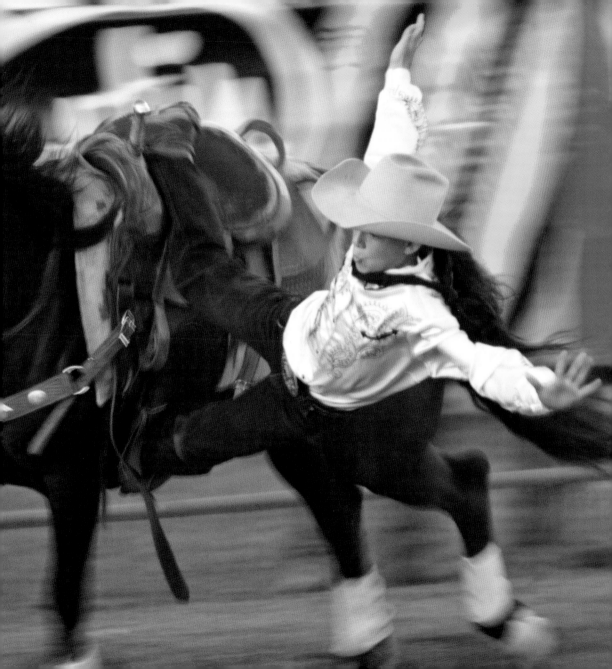

FORT UNION

"Welcome," says the man dressed in the straw hat, black vest, and white shirt. "Welcome to Fort Union. Look around. You'll see beads, fox pelts, and old stem pipes. Beaver blankets are now going for $150."

You've entered a time warp and it is easy to buy into delusion, for everything seems so real. Count the stars on the flags. Rather than fifty there are only thirty, meaning that you should place yourself in the year 1851 when traders met with their Indian neighbors. Few settings could have been better suited, for the fort is adjacent to the confluence of the Yellowstone and Missouri Rivers, and at this juncture the two bodies of water seem just as wild and free as ever.

Fort Union Trading Post was established in 1828 by the American Fur Company, and is located on the Montana/North Dakota border, twenty-five miles north of Sydney. It was not a government or military post, but a business, established for the specific purpose of conducting trade with the Indians. Here, they peacefully swapped buffalo robes for beads, guns, blankets, knives,

For directions, hours, and more information on Fort Union Trading Post, visit the National Park Service at www.nps.gov/fous/index.htm.

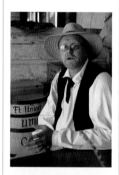

cookware, and cloth. This trade business continued until 1867, making Fort Union the longest-lasting fur trading post in North America.

Because of the old fort's significance, in 1966 the National Park Service bought the historic lands and soon began to reconstruct. As a guideline, they relied on paintings of the many artists who had visited the fort.

The people interpreting the fort seem so genuine to the setting, infusing the fort with an authenticity that goes beyond their period dress. Mike Casler, one of the "traders," says important historic events took place in the area. Just two miles downstream at old Fort Buford, Sitting Bull surrendered to the US government. In 1876 he defeated General Custer, but subsequently fled to Canada. Four years later when the buffalo gave out, Sitting Bull and his people returned, surrendered, and then accepted their new reservation existence. It was a tragic ending to a way of life.

Here, though, this history is countered by memories of more frivolous times that seem so real in this well-preserved slice of the past.

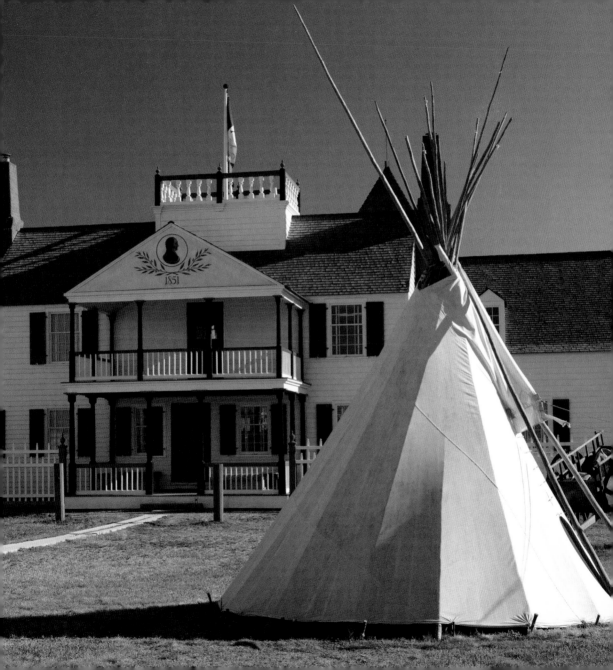

MAKOSHIKA STATE PARK

Makoshika was taken from the Lakota Indian word meaning "land of bad spirits," and if you hike through these badlands at a time when the mercury soars to 105°F or dips to 40° below, you'll know about bad spirits.

But visit this park when it is cool and when evening shadows are infusing the park's rocks with a reddish glow, and you'll know about good spirits—and an abundance of them, for at eleven thousand acres, Makoshika is Montana's largest state park.

The park owes its existence to the encroachment of several vast inland seas, each of which provided a legacy of influential deposits and features such as the tabletop rocks and stately spires. Some of these features can be seen along the Cap Rock Trail, characterized by the formations for which it was named.

Also, the park's three main trails take one back sixty-five million years, to the Cretaceous Period, a time when paleontologists believe dinosaurs died out. But prior to that time the park was

To tour the park and visit the newly renovated interpretive center, find directions and hours at www .makoshika.org.

a swampland, and visitors and scientists still find an abundance of fossils. Most likely you're familiar with some: the three-horned *triceratops,* the massive flesh-eating *Tyrannosaurus rex,* and the *Thescelosaurus.* All are displayed at the park's visitor center.

But everything is not a story of the past, and spring ushers in carpets of prairie flowers and birds of distinction.

In fact, the park sets aside a weekend to honor the return of the turkey vulture, which nests in the park's badlands. But don't stand beneath one of their nests or you may learn about "bad medicine," for turkey vultures discourage your intrusion by regurgitating the contents of their stomach all over you!

But you can watch vultures under more normal circumstances, toward day's end as they extend their wings and lift off in a dihedral formation. Watching these coal-black birds fly above a landscape now turning pink is part of the park's "good medicine," and most likely you'll be taking some of it with you.

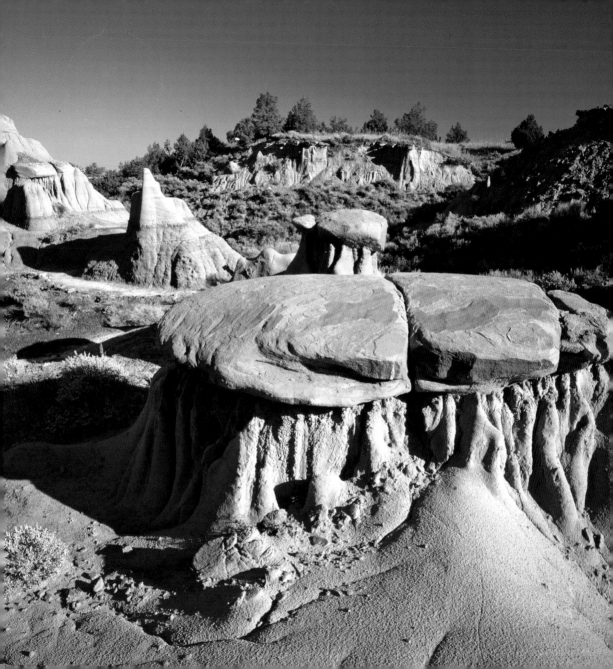

MILES CITY BUCKING HORSE SALE

The cowboy from Circle, Montana, made a poor showing, though he tried. Spurring horse No. 101 high on his flanks and leaning back in the saddle, the cowboy looked good as he exited the chute, but he lasted only past the horse's second hind-legged kick.

Horse No. 101 leaped high into the air, then kicked up its hind legs, higher than any preceding horse of the day— higher, some thought, than any horse in recent memory. The cowboy from Circle was an experienced rider, but he didn't stand a chance. On the second kick, he was flung from his saddle. Moments later he lay sprawling on the ground, but as the announcer said, the cowboy need not be ashamed. He'd ridden a top bronc.

Indeed he had, and the rodeo crowd sensed a quality animal. Wiping the tops of their beer cans and taking quick swills, they cheered loudly. That was the announcer's cue to continue with the business of the day. In typical auctioneer jargon, he began his prattle, giving voice to run-on sentences:

"Do-I-hear-three?"

The crowd gasped and then settled into a momentary silence, waiting for

Every May, Miles City comes alive with horse races, rodeo events, street dances, art shows and live music. Horse purchases are optional.

a counter, which everyone knew would soon follow.

The bucking horse sale provides a proving ground for horses that will soon appear in some of the nation's largest rodeos. Not surprisingly, many of these horses come from Montana's rugged plains, and each spring they're herded to auction. For instance, Horse No. 101 had wintered on the prairie north of Miles City, near Jordan.

The Bucking Horse Sale is the product of both social and economic needs. This particular event resulted from an informal gathering of stock contractors back in 1914. Eventually the gathering evolved to become the number-one attraction among Montanans, who love to watch the cowboys and listen to the run-on banter of the announcer.

"Do-I-hear-six thousand?"

Amazingly, horses now sell for six thousand dollars plus, often getting quick name changes. Horse No. 101 might soon become "Shotgun" or "Tornado." For rodeo folks that's good news, but maybe not for the cowboy from Circle, whose pride will likely demand he mount that horse again.

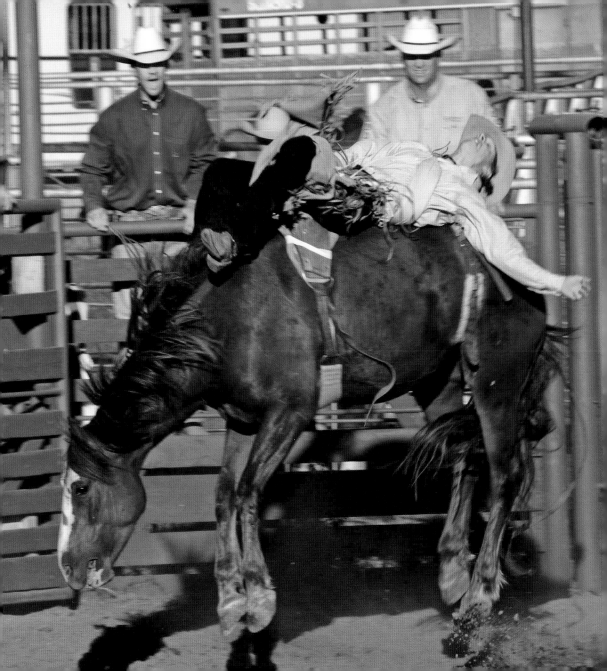

POWWOW TRAIL

At Indian Days in Browning, Montana, one of the first dance ceremonies features a Blackfeet Indian garbed in dress that includes feathers of the sharp-tailed grouse. Mimicking the bird, which ruffs up its plumage then pounds its feet, the tireless man dances around the circular arena. At several points announcer Chief Earl Old Person invites the audience to join in. "Okay," he intones, "let's everyone dance." That is the signal that people of all cultures can participate in this symbol of the circle of life.

Powwows have become a natural part of summers in Big Sky country. Such ceremonies, which help Native Americans maintain pride in their rich heritage, had been outlawed in the 1880s. Essentially an overarching government believed dancing and chanting generated excessive feelings of confidence among participants. But in the 1920s things changed, and many of the state's natives grew back their braids and then, paradoxically, began sharing a part of the culture in about a dozen different powwows.

Crow Fair is one of the largest powwows and represents the annual celebration of the Apsáalooke Nation. Held the

For an insider's view of these Native American celebrations and their significance see www.black feetcountry.com/ naid.html.

first weekend of August at Crow Agency, participants erect over 1,200 teepees, making it the "Teepee Capital of the World." As with other such celebrations, it sets the stage for rodeos, dance and drum competitions, and the mystifying Stick Game Tournament. Which hand holds the bones? The opposing team attempts to confuse designated speculators with mesmerizing chants, swaying torsos.

Satisfying as the sum of all events might be, it is the dancing and chanting that remain so memorable. Appropriately, most powwows begin as some respected tribal members carry the eagle staff into the circle. Flag bearers and dignities follow, but then come the hard-core, devoted dancers, sometimes grouped according to garb, such as the women's fancy-shawl dancers.

Present, too, are dancers who celebrate the eagle and the grouse. Interspersed is the invariable call: "Let's everyone dance."

That call not only invites attendees to acknowledge their place, with peoples of all cultures, in the circle of life, but also provides a singular opportunity to honor native traditions.

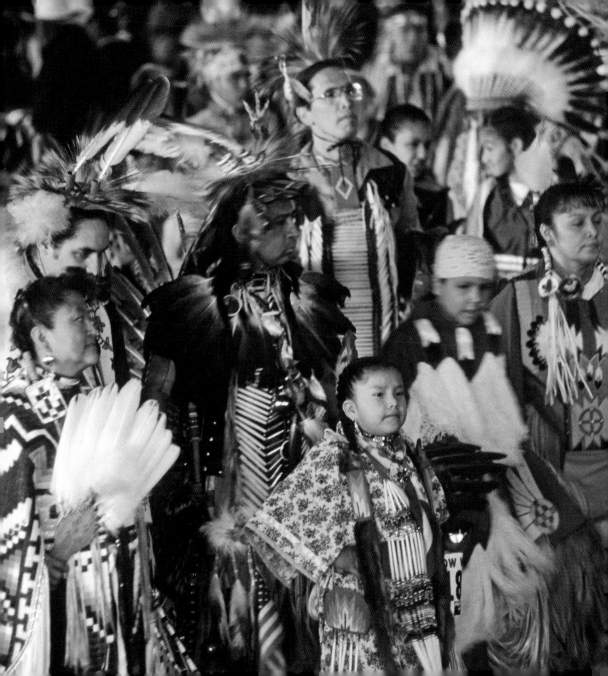

LITTLE BIGHORN BATTLEFIELD
NATIONAL MONUMENT

In November of 1991, two years after Barbara Sutteer became the first American Indian to serve as superintendent at Custer Battlefield, she answered her telephone to a chorus of chants.

"They were singing the Cheyenne victory song," said Sutteer. "And the caller was telling me that Congress had just approved legislation to redesignate Custer Battlefield to Little Bighorn Battlefield and had authorized the construction of a new Indian memorial." She said changes were the direct result of a new spirit of unity, emphasizing that that spirit was "a long time awakening!"

Three years after Custer's June 1776 defeat, the army established a national cemetery to honor all veterans, both native and nonnative. Then in 1881, it set aside land to honor those who fell with Custer. But to the dismay of natives, "they designated the grounds as the *Custer* Battlefield," thereby setting the stage for "a century of dishonor."

And that's the way it remained until one June day in 1988 when Indian activist Russell Means led a group from the American Indian Movement to the top

A privately run reenactment of the battle is held every June 25. For official National Park Service events and offerings at this site, visit www.nps.gov/libi/index.htm.

of Last Stand Hill. Here, they imbedded a metal plaque among the headstones of those who died with Custer. The plaque's inscription extolled the "Indian Patriots" of 1876 who "fought and defeated the U.S. Cavalry in order to save our women and children from mass murder."

After that, much began to change. Of course the Custer story must be told. But today we also hear of Indian bravery and we see a grand memorial that celebrates a new spirit of cooperation.

Completed in 2009, the half-acre memorial conveys a spirit of peace and unity, establishing an integral relationship between Indian warriors and the Seventh Cavalry Monument. This relationship occurs at the point where the axis of the monument bisects the earthen enclosure. Here, in the words of the designer, *". . . a weeping wound or cut exists to signify the conflict of the two worlds. Two large adorned wooden posts straddle this gap and form a "spiritgate" to welcome the Cavalry dead and to symbolize the mutual understanding of the infinite all the dead possess."*

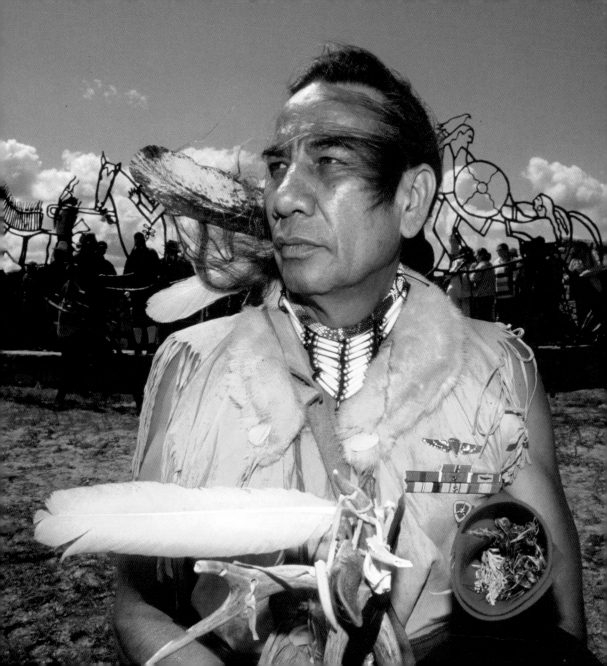

BIGHORN CANYON

Among many Native Americans, Bighorn Canyon Recreation Area is a place that was established on a sour note. I heard the story back in 1981 from Bob Yellowtail, the man who almost stopped the government cold. Engineers wanted to build a dam, but Yellowtail said the river had been sacred to the Crow people and he fought tooth and nail to prevent its construction. He lost, of course, but because he fought so eloquently and so convincingly, the University of Montana eventually awarded him an honorary degree in law. And then, whether or not it was intentional, the government slapped Yellowtail with what he considered the ultimate insult. "They called it," said the much revered Crow elder, "Yellowtail Dam."

Despite the ignominious beginning, time has softened hard feelings, and most have accepted that which cannot be changed, focusing instead on the benefits of the dam and enjoying access to the land around it.

The Pryor Mountains are contiguous with the reservoir and they host a wild-horse herd that descended directly

Bighorn Canyon (www.nps.gov/ bica/index.htm) is located about ninety-five miles south of Billings.

from horses brought to North America by the Juan de Onate expedition of the 1600s. For years some disputed the lineage, but modern-day advancements in genetics have provided techniques to prove heritage. What's more, these horses have specific characteristics, such as "zebra" stripes on the back of the forelegs. Because they are free ranging, visitors often see stallions engaged in battles for possession of developing harems.

Bear, elk, and deer also inhabit the Bighorn area, and—demonstrating the aptness of its name—so do bighorn sheep. The Bighorn Canyon National Recreation Area was established in 1966 by an act of Congress; shortly after, the Bureau of Reclamation began construction of the Yellowtail Dam. The dam created seventy-one-mile-long Bighorn Lake, which provides excellent fishing. Of course, this area would still attract recreationists and anglers even without the impoundment, but if nothing else, the Yellowtail Dam reminds us of a brave and honorable man whose voice was heard, even if it was ignored.

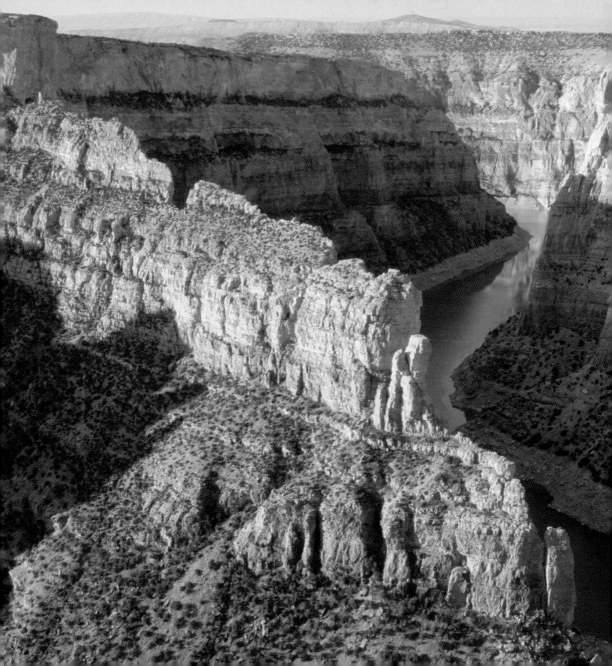

BEARTOOTH HIGHWAY

Splat! The crunchy snowball struck me in the back of the neck, and I was startled because morning temperatures were in the high eighties just a few hours earlier when we left the Montana prairies and began straining our way over Montana's Beartooth Highway.

This road of unparalleled beauty begins at an elevation of about five thousand feet and climbs to almost eleven thousand feet. Because every one-thousand-foot gain in elevation is equivalent to driving five hundred miles north at the same altitude, biologists say that when you drive this highway, it's like driving from the Montana prairie to the Alaskan tundra.

It was an August day, and at this high elevation we paralleled a stream that was probably fringed with ice less than an hour earlier. In these high elevations, the pace of life is quick, and everything seemed more intense. The sun was brilliant, the shadows dark, and the skies a deep, deep blue—as though seen through a polar-

Some say the Beartooth is the nation's most beautiful highway. For more information, go to www.mdt.mt.gov/travinfo/beartooth.

izing filter. The air was pure, and we could see great distances; then, just past a point where the road looped back on itself, Beartooth Peak burst into view.

Surrounded by ice and snow, we seemed to have traveled to a far different land. It was here that Janie had scooped out her ball of snow. Indeed, it seemed we were in the Alaskan tundra, making this—in the metaphorical sense—one of the world's longest of drives.

But there's another way of describing this high-plateau route. Charles Kuralt said the Beartooth is America's "most beautiful highway," and we humbly agree, though we still like the biologist's metaphorical image.

You can make the sixty-four-mile drive from Red Lodge to Cooke City (just outside of Yellowstone National Park) and then decide whether this route from prairie to Arctic tundra is the nation's most beautiful drive—or its longest.

Of course, it could be both.

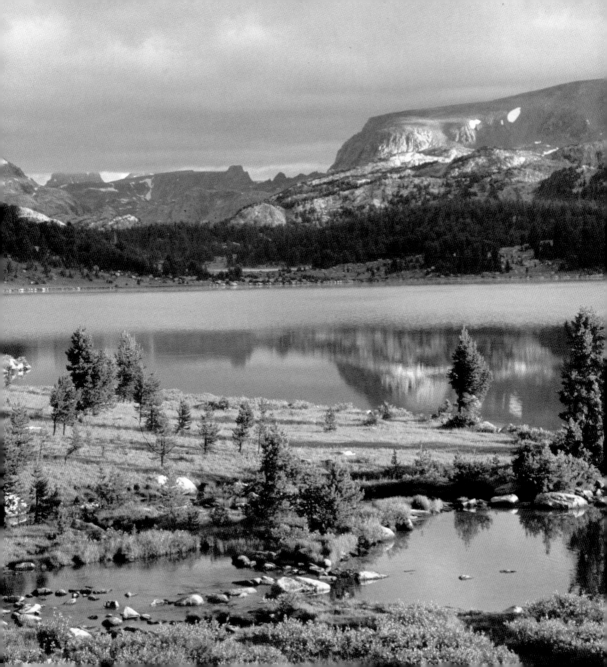

CHIEF PLENTY COUPS STATE PARK

On the Crow Indian Reservation, about fifty miles south of Billings, "warriors" had assembled to re-create the Arrow Creek Battle, famous in tribal history. Galloping across the land, painted braves thrust out their battle sticks and struck their enemy. In this way they counted coups, and their actions reminded the Crow people of the valor of their most revered chief.

Designated Chief Plenty Coups because he counted coups (struck his enemy) so often, the famous Crow leader proved himself in yet other ways. Frequently, he captured tethered horses, one of the four war deeds required to become a chief.

In later life, Crow Indians designated him "Chief of All Chiefs," and he helped bridge the gap between two cultures at a time when that rift may have been at its greatest. Appropriately, in 1965, the state of Montana established a park in his memory. Land for the park came from Plenty Coups himself, who gave up his nomadic ways and became one of the first of the Crow to settle on a farm. Here, he opened a store, built a home (now a National Historic

Hours, directions, photos, and more of this state park can be found at http://state parks.mt.gov/ parks/visit/chief PlentyCoups.

Landmark), and tilled the earth until his death in 1932 at age eighty-four.

Though Plenty Coups' accomplishments were many, perhaps his most significant contribution was to his disheartened people. In 1908 he united his fractured tribe in the battle to prevent white settlement on the reservation. Respected by both natives and non-natives alike, in 1921 Plenty Coups represented all Native Americans in Washington, D.C., at the dedication of the Tomb of the Unknown Soldier.

Today, an elaborate museum in the state park displays his memorabilia and interprets Crow culture. Curators work with tribal members to develop guidance for the respectful handling of sacred items such as Plenty Coups' war bundle, which contains the legs of the chickadee, his spiritual guide. He was quoted in later life saying that his prayers and luck had always been strong.

His "medicine" must still be good, for warriors still recall with mock battle and superior horsemanship the valor that so characterized their "Chief of All Chiefs."

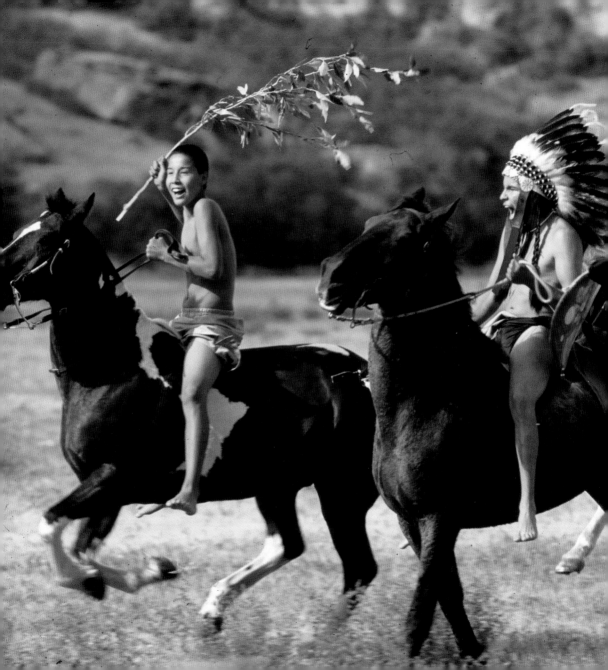

BILLINGS: MONTANA'S TRAILHEAD

Because of its phenomenal growth from its founding in 1882 as a railroad town, Billings was nicknamed the Magic City. If growth provides the rationale for such a sobriquet, the name should remain, for growth is expected to escalate. Demographers believe the Bakken and the Health Shale Formations just north of Billings—said to be the largest oil discovery in the United States—will add substantially to the city's existing population of 104,934. Already, Billings is the state's largest city.

Perhaps, however, that is not the image the city leaders wish to project, for in 2011 they authorized a new city nickname that seems more relaxed. Henceforth, Billings will be known as "Montana's Trailhead."

One fall night I got a sense of their rationale when I drove from "the world's first KOA" in Billings to a parking lot in Swords Park, near the airport. From there a trail took me along the Rimrocks, sandstone cliffs ranging in height from five to eight hundred feet and running east-west all the way through town.

If you're planning to make Billings a destination, check out www .visitbillings.com for information on what to do and see while you're there.

From below I could hear the occasional yip of a dog, music of various types, and chants reminiscent of American Indian powwows. Surrounding all this and visible from my lofty vantage, were six mountain ranges, and though I could also see an oil refinery, it was the dominance of the Yellowstone River and all the history and beauty it projected that finally crystallized my thinking. Indeed, Billings did seem like a trailhead, and for many it actually was.

Yellowstone Kelly, who lived from 1849 to 1928, created a reputation as a frontiersman. As Yellowstone National Park's first park ranger, he was one of my heroes. Kelly was buried near the edge of the Rimrocks, meaning Billings will always be a trailhead for this early day adventure/traveler.

And so it is for many others. Just as in the past, "trails" from Billings lead to over half a dozen nationally recognized areas, such as the Little Bighorn. And then there are the trails within the trailhead city, and they should be followed too.

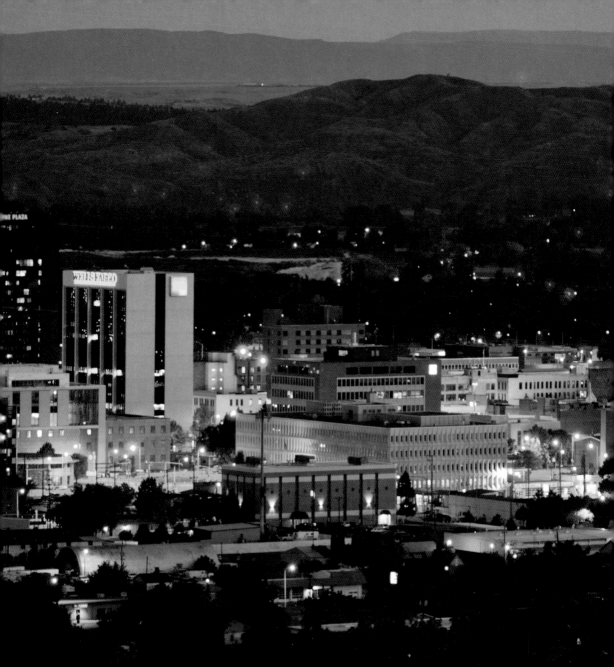

POMPEY'S PILLAR

On July 25, 1806, William Clark climbed a rock formation along the Yellowstone River, prompting an extensive journal entry that applauded the view and the formation. Clark carved his name into the sandstone edifice, and today his signature remains the only physical evidence from along the route of the Lewis and Clark Expedition.

That's monumental, but perhaps even more significantly Clark named the prominent sandstone formation in a way that would honor the Corps' Shoshone guide, Sacagawea. Clark named the formation after her son, Pompey, celebrating a life that would resonate with adventures of his own.

The expedition concluded in 1806, but Sacagawea and her husband, French-Canadian trader Toussaint Charbonneau, spent three years among the Hidatsa before accepting William Clark's invitation to settle in St. Louis, Missouri. In 1812, an obscure disease took Sacagawea's life, prompting Clark (by now the Superintendent of Indian Affairs for the Louisiana Territory) to submit adoption papers. On August 11, 1813, Pomp (Jean Baptiste) became Clark's foster son.

This sandstone prominence is presumed to be the only site where Captain William Clark left evidence of his passage.

After schooling, Jean Baptiste's celebrity status encouraged an adventurous life. When eighteen he was befriended by a German prince who took him to Europe, where he lived among royalty and learned four languages. Jean Baptiste returned to the states, working first as a gold miner and later as a hotel clerk. In 1846 he led a group of Mormons to California and subsequently became a magistrate for the San Luis Rey Mission. As a "half-breed" he objected to the way Indians were treated at the missions and resumed work in Auburn, California, as a hotel clerk.

Forever restless, at the age of sixty-one he left California for the Montana gold fields, but never made it, dying in Oregon of pneumonia on May 16, 1866.

In life Jean Baptiste remained celebrated as the infant who went to the Pacific Ocean and back with his famed mother and the Corps of Discovery. Pompey's Pillar memorializes that life by preserving a sandstone edifice that was once a prairie beacon. In January of 2001, it was declared a national monument.

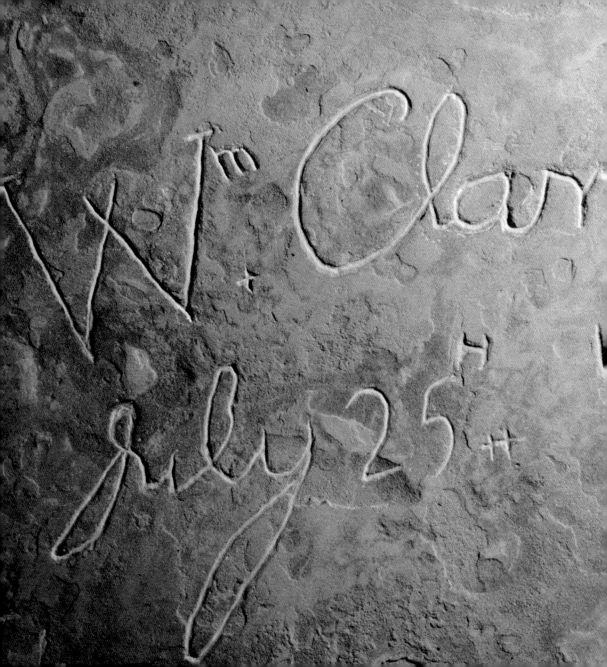

HUTTERITES

John Hofer dresses plainly. He wears a coal miner's cap, black coat, plaid shirt, and black wool pants. Because he is married, he wears a beard, but no mustache.

John's wife also dresses plainly. Each day she wears a print dress that extends past her ankles, an apron, and a polka-dot scarf that covers her hair.

The Hofers live in a lengthy barracks-style complex that houses five families. There is no television inside their unit, nor is there a radio or a stereo. The scant furnishings are all made locally. Though some people in their community drive, vehicles are few and used collectively.

The lifestyle of the Hofers is modest to an extreme. But when John goes to work on the communal farm shared with one hundred others who comport themselves in an identical manner, he uses only the most sophisticated of agricultural techniques, such as computerized monitoring of the weight gains (or losses) of the hundreds of sows he supervises.

"It's our simple ways," says Mr. Hofer, "that help us do so well in life."

The Hofers belong to a religious sect

Sometimes colonies open their doors for guests, but anyone interested in visiting should conduct research. A good place to start is www .opi.mt.gov/pdf/ Bilingual/EU_ Hutterites.pdf.

known as the Hutterites, and indeed they do achieve. Hutterites are among Montana's most successful agriculturalists, and as a group, their lives are exemplary. Crime and divorce are nonexistent, and drug and alcohol abuse is rare. They do not believe in war. Throughout Montana, Hutterites are perhaps best known for the high quality meat, produce, and dairy products they sell locally.

Like most major Protestant groups, Hutterites originated as a sect in part because of the Great Protestant Reformation of the 1500s. Seeking independence from the Catholic Church, Jacob Hutter founded a religion based on his own biblical interpretations. But he was considered a heretic and burned at the stake at Innsbruck in the Tyrol in 1536.

Hutterites continued to be persecuted throughout Europe and around 1870 many fled to the United States. Today, over four thousand Hutterites live in Montana, divided into forty-one colonies scattered throughout the remote prairie areas. Another twenty-eight thousand live in remote areas of the Dakotas, Minnesota, Washington, Alberta, Saskatchewan, and Manitoba.

DINOSAUR TREASURE TROVES

"*It's like a smoking gun,*" said Nat Murphy, a Montana anthropologist who discovered his *Brachylophosaurus* in the fossil-rich prairies adjacent to Malta, in north central Montana. "Not only is it perfectly preserved but food has been found in both the stomach *and* colon, so paleontologists can tell not only what it ate immediately prior to death, but what it ate over long periods of time."

"If you dig dinosaurs," quipped Murphy, "Montana's the place to be."

One really cool place to begin an adventure is the Museum of the Rockies in Bozeman, Montana, which displays most of the state's fabulous finds and boasts the world's largest *Tyrannosaurus rex* collection. With luck, you may also meet the world-famous museum curator, Jack Horner, advisor to the creation of all three *Jurassic Park* movies. Look for a large bearded man with a shock of hair as unruly as that shown in photographs of Einstein—a man who looks as though he could really groove on creatures with names such as *Seismosaur, Maiasaura,* and *Tyrannosaurus.* If you find such a man, have your questions ready.

When asked why Montana's prairies

For a detailed route and points of interest along Montana's Dinosaur Trail, check out http:// mtdinotrail.org.

have one of the largest repositories of dinosaurs in North America, Horner explained that the Cretaceous inland sea that came and went on many occasions dropped many loads of sediment, and each time created a "formation."

Horner was involved in excavating areas within the Two Medicine Formation, which was created about seventy-four million years ago by rivers and streams, ideal for preserving fossils. In 1978, the formation yielded the discovery of dinosaur embryos, which occurred at "Egg Mountain," not far from Choteau, in northwestern Montana. It was the world's first such find.

Other formations are found along Montana's one-thousand-mile-long "Dinosaur Trail," which lends to dozens of unique Montana towns adjacent to harsh prairies over which huge reptiles once roamed. The lands are compelling but, more significantly, they often host professionally organized digs.

There's an unparalleled thrill finding the bones of another *Brachylophosaurus,* loaded with food and completely intact. Such creatures are still hidden in Montana's soil, waiting to be exposed.

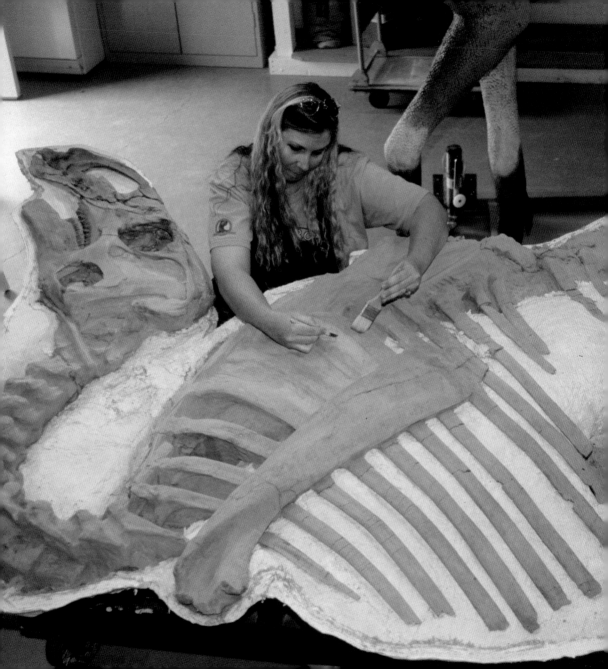

YELLOWSTONE'S THEODORE ROOSEVELT ARCH

In January 1995 an entourage of national park vehicles departed Canada loaded with eight crates, each of which contained a single wolf. The convoy was significant as it represented an attempt to bolster Yellowstone National Park's flagging wolf population. To dramatize the augmentation, park officials drove through the Theodore Roosevelt Arch, the park's first official entrance.

Four years later, members of American Indian tribes wanted to draw attention to a bison hunt near Yellowstone Park. They believed that the slaughter of bison for management purposes was ill conceived, and one hundred American Indians marched five hundred miles from the Black Hills to Theodore Roosevelt Arch. In both cases attention was directed to the words contained in the chord of the arch: For the Benefit and Enjoyment of the People.

Today, many believe that symbolism is about all the old arch is good for. In fact, at the time it was conceived, Captain Hiram M. Chittenden, director of the park's road construction, believed the entrance lacked magnificence.

Originally built to welcome railway passengers from the local depot, this towering edifice of columnar basalt continues to impress visitors to Yellowstone National Park.

And so in February 1903, rock masons began construction of a huge arch that would tower some fifty feet high. Coincidentally, several months later Theodore Roosevelt was traveling in the area and in April 1903 he laid the cornerstone for the arch. Then before a crowd of about two thousand, Roosevelt provided words for a mantra, declaring the park was "created for the benefit and enjoyment of the people."

Workers completed the arch in August 1903, and for many years visitors arriving by train had to access the park through the arch. But by 1930 automobile usage increased, and engineers built a road through Gardner that short-circuited the historic structure. Today's road takes drivers directly to an entrance station, and because the route cuts out about half a mile of driving, most bypass the arch. But not all. Sometimes activists require drama, and when they do, they strike up a metaphorical band and promenade through the arch. Because they are rubbing shoulders with Teddy Roosevelt and national park history, their choice is often effective.

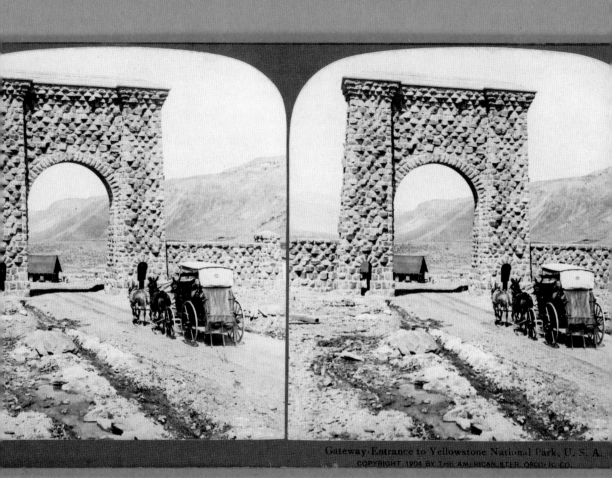

VIRGINIA CITY'S BREWERY FOLLIES

When you buy the eighteen-dollar ticket for the Follies they tell you right up front: "You know, don't you, that this is adult entertainment?" Adding, "If you're not comfortable with off-color jokes and sometimes a little political satire, this program may not be for you."

Of course that may be the tantalizing come-on you need to attend the Brewery Follies, held in an old saloon in Virginia City, Montana. But if it's not, then all you have to do is stick up your nose, saying in so many words, "These are not my type of boys and girls. I'm above this." Be assured your moral certitude—and subsequent departure—will garner little applause.

We, on the other hand, stuck around last August to see four young talented men and women provide acts that were rehearsed to perfection. Each could sing or dance and create audience participation. And all could poke fun in a way that didn't antagonize.

Don Furhman played the part of a jilted gay lover, Bobby Gutierrez was a suave Italian Romeo, and Brit Buchan seemed involved in everything. Sometimes two or more of the four acted out

The Brewery Follies is held each summer in the H.S. Gilbert Brewery in historic Virginia City. For more information, visit www.virginiacity.com.

parts together, as when Gutierrez and Furhman paired up to portray a couple of detectives. In another skit, Arcadia Jenkins and Buchan created a dialogue in which they discussed the ten things a man and woman who are romantically involved should never ever do. Now, here you can let your imagination run wild.

Everyone in the audience seemed to have a favorite, but Jenkins, who dramatized the part of a young girl trying to win a lover, rated high. She garnered applause with ribald humor and gestures that were exaggerated to the extreme.

"Ooooooooo," she said with a degree of sexual explicitness, pain, understanding, and naivety, all rolled into one. "We may be getting somewhere now. Ooooooooooooooooo."

Not everyone can create laughter by appearing forlorn, vexed, simple, sexy, and wise, but Jenkins possessed the necessary mannerisms and dialogue. The four men and women worked well together, and if you are looking for some pretty darn good talent, Virginia City's Brewery Follies continues to remain on the cusp of creativity.

LEWIS AND CLARK CAVERNS

Almost from the moment we stepped onto a stone stairway that would take us deeper into the Lewis and Clark Caverns, the lights went out. Few had head lamps, so our descent was spooky. To maintain balance Janie and I both grabbed hard to the cold, iron railing.

State tour guide Laurie Koepplin pointed out that these conditions were similar to those who first discovered the caverns in 1892. "Imagine," she suggested, "that all you had was candlelight."

Our adventure in the dark was short-lived. Power was quickly restored and everyone gasped as Townsend's big-eared bats swooped over our heads. "They're harmless," said Koepplin, "just settling in for some rest."

Though most found all the conditions intriguing, the slippery rock and tight space concerned one individual who elected to go back. Coincidentally, we had reached "Decision Rock," a point at which guides customarily ask visitors if they're apprehensive.

Koepplin continued her narration, explaining that although Lewis and Clark had passed nearby, they never mentioned the caverns in their journals.

To find out when tours are available—as well as to view more mesmerizing pictures of this natural wonder— visit http:// stateparks .mt.gov/parks/ visit/lewisAnd ClarkCaverns.

"Most likely," she said, "it's because they never saw them."

Indians knew of the caverns, but it remained for two local ranchers to introduce them to the world. During a November hunting trip, cold air had flushed out the warm air, creating a funnel of steam that drew the men to the opening. They descended, soon discovering over a mile of interconnecting chambers. Eventually entrepreneurs began offering tours into the caverns, but in 1908 the federal government assumed management, and then, in 1935, the caverns became Montana's first state park.

Typically, state tours are two hours long, and as we continued the descent our eyes quickly adjusted, and the formations seemed to become more and more spectacular. Koepplin pointed out stalactites and stalagmites as well as formations that looked like popcorn, flowstone, and "cave bacon."

Though the caverns are the main attraction here, the park also offers an extensive series of hiking trails, many of which parallel the beautiful Jefferson River, up which Lewis and Clark traveled so many years ago.

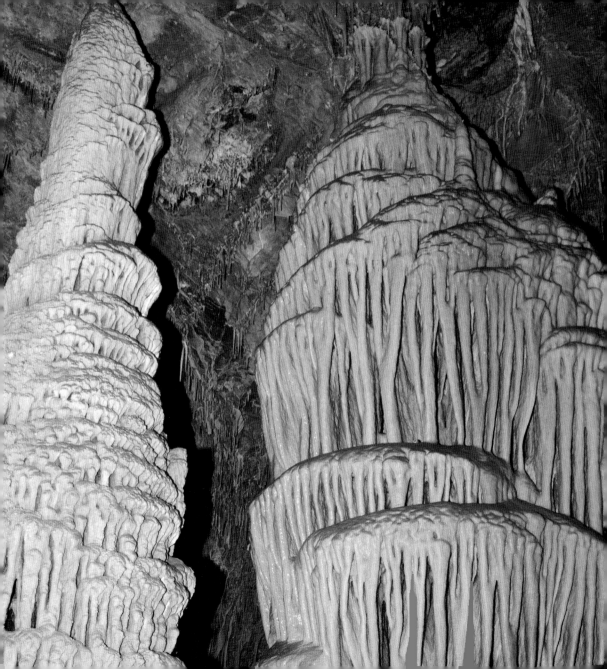

HEADWATERS STATE PARK

So many travelers passed through what is now Montana's Headwaters State Park that one is tempted to call it one of the most significant state parks in the nation. An added attraction is that so little has changed, making it a living legacy of the past.

From the top of a relatively low prominence called Fort Rock, one of the most significant geographical features in all of North America unfolds, still appearing wild. To the west, one can see the confluence of the Jefferson and Madison Rivers. In the other direction just half a mile away, these two rivers then converge with the Gallatin to form the Missouri River. Huge mountain ranges surrounding this setting include the Bridgers, the Madison and Gallatin Ranges, and the Tobacco Root Mountains, often covered with a dusting of snow.

When Lewis and Clark arrived here, they initially believed that no stream was the Missouri River proper, but that the three waterways together formed the longest river in North America. In his

If you want to camp where Lewis and Clark stayed in 1805, then visit http://stateparks.mt.gov/parks/visit/missouriHeadwaters/.

journals Captain Clark noted the abundant wildlife: "I saw several Antelope, common Deer, wolves, beaver, otter, Eagles, hawks, crow, wild geese, both old and young, etc. etc."

All the area's major tribes visited the headwaters to hunt, and later the Three Forks was visited by trappers. Legend has it that it was here that the Blackfeet captured John Colter, stripped him of his clothes and then told him to run for his life. A fast runner, Colter eluded all of the runners save one who was closing in with a spear. Before the warrior could thrust the spear, Colter grabbed it and killed the man. Then he dove into the Missouri and hid from his other pursuers beneath a raft of reeds. Such are the legends that still echo at the headwaters, and that a state park now interprets.

The Heritage Trail departs from the campground inviting cyclists and hikers. In the fall a sign warns that the area is moose country, that bulls are in rut, and that hikers should be careful. In other words, a legacy remains.

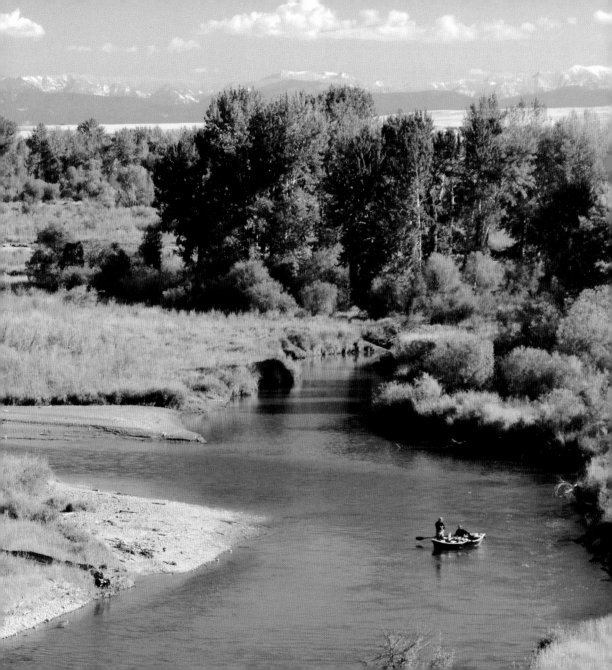

STATE CAPITOL IN HELENA

The stock brochure available with tours of the capitol glosses over some of the "meaty" aspects of the state's more influential first residents. In some ways that's unfortunate, as Montana leaders often led fascinating, if not exemplary, lives. One of the state's first governors is an example, and materials at hand ignore the fact that the man had a vitriolic temper and that when he drowned (an act of murder, say some) in the Missouri River in 1867, he was intoxicated.

Of Irish extraction, Thomas Francis Meagher had been a revolutionary during an 1848 uprising, during which time he had been captured, then sentenced to be drawn and quartered and then hanged. He escaped and eventually helped shape the destiny of the United States, and for those rough-and-tumble times, Meagher was undoubtedly what Montana needed.

The interior of the capitol building also recalls the state's history captured in exquisite paintings. Peering toward the dome one sees life-size art works symbolizing the various eras of Montana. Surrounding the dome is an Indian, a

Guided tours of the capitol are available throughout the year, with limited hours during the off-season. For more details, go to http://visit-the-capitol.mt.gov.

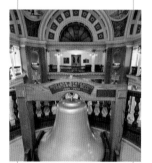

trapper, a miner, and a cowboy.

Appropriately, cowboy artist Charlie Russell's work is present. This once youthful malcontent from St. Louis ran away from home to eventually find himself in Montana, where he matured to create great works of art. His colossal mural of Lewis and Clark meeting Indians at Ross's Hole now graces a room in the west wing, and it is here that Members of the House of Representatives meet, hoping to create a better Montana.

The capitol contains many other features, with some particularly eye-catching improvements made during a major renovation that was completed in 2001. There's a listing of Montana's most prominent citizens, many beautiful statues, and a huge bell recalling the state's first one hundred years. There's the office of the governor, staffed by people who make you feel welcome. And among many other things, there is a quote from Pulitzer Prize–winning novelist A. B. Guthrie, who says that Montana has served as "[his] point of outlook on the universe. . ."

So it has been for many others.

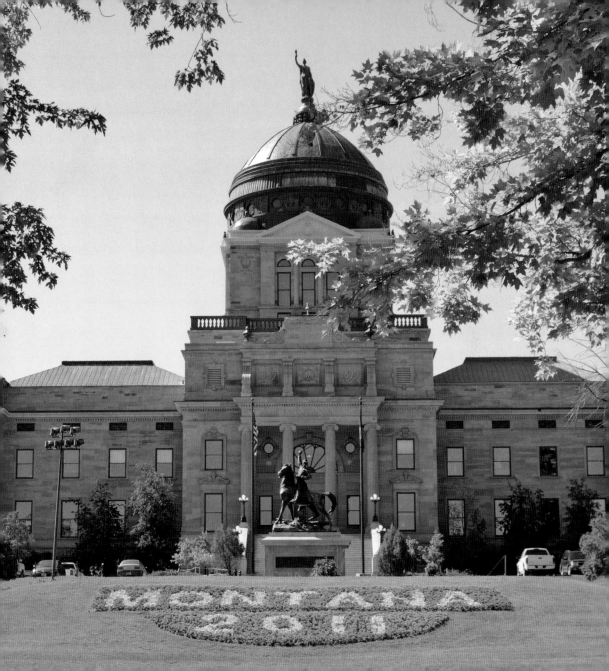

THE GATES OF THE MOUNTAINS

On July 19, 1805, the Lewis and Clark Expedition encountered an area of the Missouri River near present-day Helena that they considered remarkable.

"This evening," wrote Captain Lewis, "we entered . . . the most remarkable clifts that we have yet seen. These clifts rise from the waters edge on either side perpendicularly to the height of 1200 feet. . . . The river appears to have forced its way through this immense body of solid rock for the distance of 5-¾ Miles. . . . I called it the gates of the rocky mountains."

Since observed by Lewis and Clark, others have added to the description, saying in so many words that the towering limestone gorge, etched with three-hundred-million-year-old marine fossils, at first "appears to block further passage," adding that as one approaches, the walls of the gorge seem to open like "two giant doors" and "passage is accomplished."

Today, the river and surrounding features are but little changed, though many more stories are unveiled as you pass through this portal. Some of the stories are tragic, some intriguing.

Visit www.gatesofthemountains.com for up-to-date schedules and rates for these two-hour boat tours. The beautiful scenery and knowledgeable guides make this trip well worthwhile.

Near the entrance is a remarkable panel of pictographs. The panel is interesting because it seems to paint the picture of a buffalo falling off a cliff, suggesting the presence of a bison jump in the area.

Another story secreted in the Gates is a tragic one, described by Norman Maclean. In his book, *Young Men and Fire,* Maclean (first made famous with his book-turned-movie *A River Runs Through It*) chronicles the tragic death of thirteen young smoke jumpers. Might they have survived had they lain down in a burned-over area as the foreman had commanded? No one will ever know. Moreover, the "escape fire" technique had not been part of their training. Dodge (the foreman) later stated that one crew member exclaimed, "The hell with that, I'm getting out of here!"

As a welcome addition to the bald eagles and other abundant wildlife, in 1951, twenty-seven mountain goats were introduced into this rugged mountain region. The herd has enjoyed periods of great health and often can be seen scrambling nimbly through the limestone scree, making the *clifts* a most remarkable area.

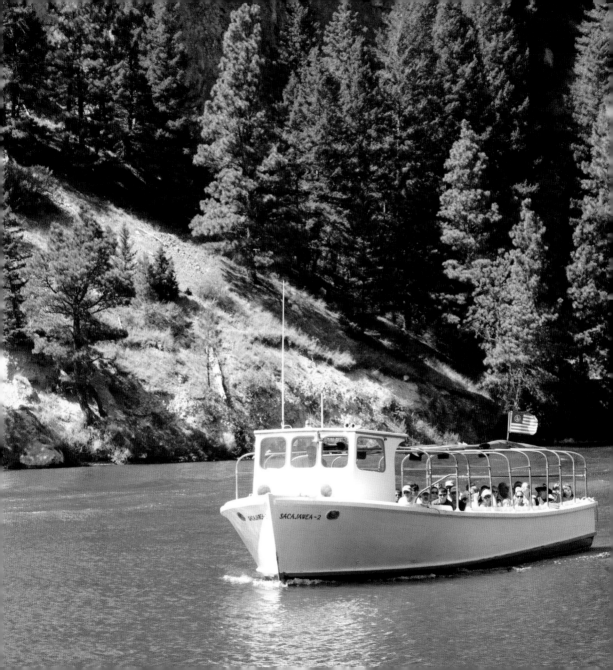

THE GREAT FALLS OF THE MISSOURI

After trying on the replica cradle board displayed at the Lewis and Clark Interpretive Center in Great Falls, my wife came to believe that teenage guide Sacagawea was one tough woman. Each day while trudging along with the twenty-nine men in the Lewis and Clark Corps of Discovery, this much celebrated Indian woman carried her infant son, Pompey, who was only growing heavier. For two long years, she struggled with the captains, but her greatest challenge may have been the period the Corps trudged around the Great Falls of the Missouri, which comprised five separate falls. Between June 13 and July 15, 1805, the Corps fought exhaustion, rain, hail storms, excessive heat, bears and bison—and the prickly pear, which constantly pierced their double thick moccasins.

The Interpretive Center's focus on the Corps' adventures begins from the moment one enters the huge complex. Upon entering the high-ceilinged interior of the top floor, visitors are greeted by a larger-than-life assemblage featuring men from the expedition struggling to haul their canoe up a huge embankment. Sacagawea can't be far away.

For visitor hours and details about this complex portage, visit www.lewisand clarktrail .com/section3/ montanacities/ greatfalls/lc interpretive/ index.htm.

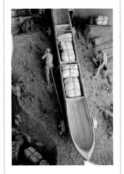

From this vantage point, floor-to-ceiling windows provide a view of a portion of the falls. Downstairs are various exhibit halls chronicling the expedition, as well as a large-screen theater that shows twenty- and thirty-minute informational films throughout the day.

Quotes from the explorers' famous journals are posted throughout the exhibits and provide baseline data on the state's once abundant wildlife populations. Lewis wrote that in one afternoon his path around the falls converged with "a bear, a mountain cat or wolverine and three buffalo bulls."

Though the Great Falls of the Missouri have been tamed, nevertheless suggestions of immense energy remain, for the impounded waters now produce hydroelectric power for much of the Northwest.

What might the Corps think of all these modifications? The question will forever remain unanswered, but what is significant is that their feats are recalled here, for one-third of their journey was spent in Montana, and an inordinate amount near the Great Falls of the Missouri.

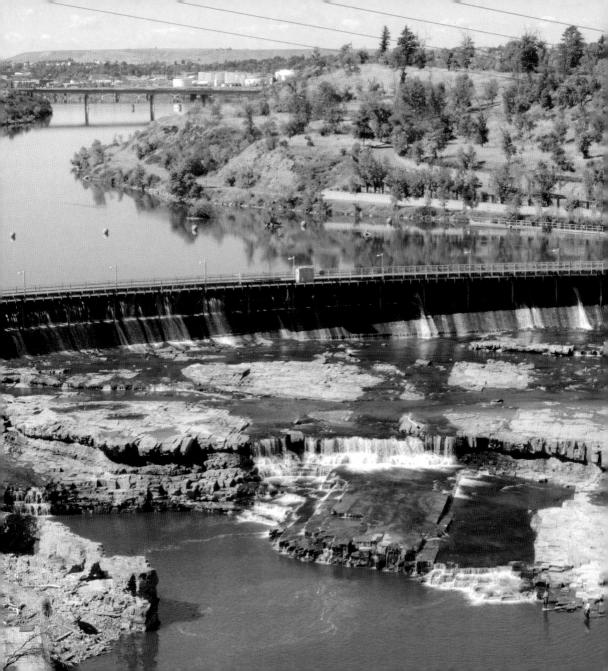

CHARLIE RUSSELL

The winter of 1886–1887 was one of Montana's most brutal. Snow at the O-H Ranch in the Judith Basin of central Montana had accumulated in drifts up to twenty feet, and the absentee owner wrote his ranch foreman asking how the cattle herd had weathered the winter. The foreman responded by sending a postcard-size watercolor of wolves eyeballing a gaunt steer.

The work had been created by a young ranch hand who had entitled his drawing, Waiting for a Chinook. The small painting is now on permanent display in the C.M. Russell Museum in Great Falls, and more than any other single event, that painting launched Russell's career.

Few western artists have created a legacy that so thoroughly documents an era, and the work of Charles M. Russell is almost synonymous with Montana's romantic image, particularly the Old West, the period Russell's art so eloquently recalls.

Born March 19, 1864, he moved to Montana as a teenager and began to live the life he soon began drawing. Today his paintings are in the state's capitol, in

For up-to-date information on hours, exhibits, and special events, visit this Great Falls museum's website at www .cmrussell.org.

so very many state bars where impression of drama is sought, and in posh restaurants seeking an atmosphere of elegance. His paintings create a mystique often summarized with descriptive titles: The Jerkline, Bronc to Breakfast, and Lewis and Clark Meeting the Flathead Indians, the latter of which graces the wall of the state house chamber. Appropriately, some public schools bear his name, as does one of the nation's largest wildlife refuges—located, of course, in Montana.

During his life he created more than two thousand paintings of cowboys, Indians, and landscapes, as well as bronze sculptures. He became known as the "cowboy artist," or simply as "Kid" Russell.

Russell also was a first-class story teller, but because he tended to be reclusive, his wife Nancy became his promoter, and helped see his book *Trails Plowed Under* to print.

Russell died in 1926, and the city of Great Falls marked his passage by releasing all the schoolchildren to watch the funeral procession. Russell's coffin was displayed in a glass-sided coach, pulled by four black horses.

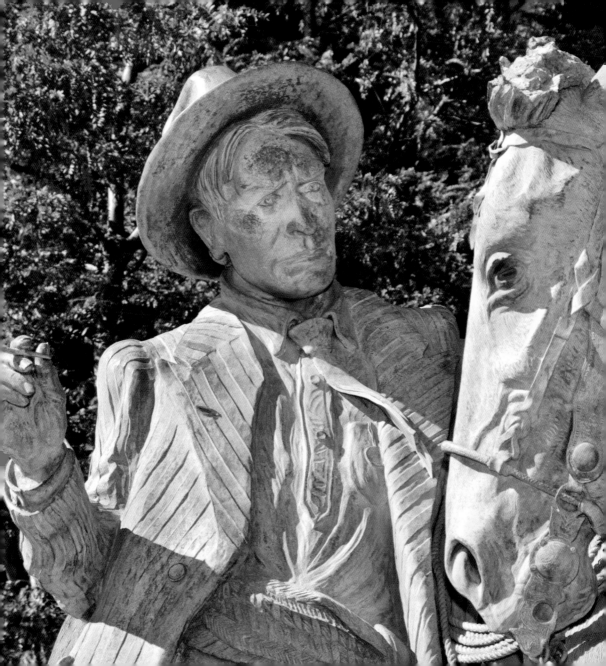

BUFFALO JUMPS

According to Clarence Three Irons, it is easier to control a stampeding bison herd than it is a milling one. That principle applied thousands of years ago, and it still applies today.

In the Bighorn Mountains on the Crow Indian Reservation in south-central Montana, Three Irons directed our wandering gaze with a wave of his arm. After only a moment's wait, a herd of about two hundred animals charged over a mountain crest. In a swirl of dust and noise, men stationed along the flanks controlled their movement so that the herd bolted down the side of a steep mountainside and then into a series of corrals for annual shots. "Not so hard?" Three Irons asked with a smile.

More recently I heard Don Fish, a Blackfeet Indian interpreter working for First Peoples Buffalo Jump, employ the same words. Fish had led a grade-school class up the side of a mile-long cliff not far west of Great Falls. Fish explained that a thousand years ago, young men would leap from behind piles of stones, and apply the age-old principle. "Imagine

Spectacular examples of bison jumps are located in Havre and near Great Falls.

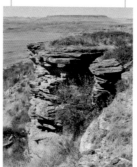

the excitement as all these young men shouted and waved their blankets."

Running hard, lead animals would approach the drop, and though they might recognize danger, buffalo charging from behind would force the front runners over the cliff. Indians stationed at the base of the fifty-foot drop would club or spear the animals to death.

Such bison harvests took place in a number of similar places in Montana. Near Havre, at Wahkpa Chu'gn Buffalo Jump, archaeologists have discovered the most extensive and best preserved deposits of buffalo bones in the northern Great Plains.

Of course, the purpose of the kill sites was to secure not only meat, but also hides for clothing, buffalo bladders for carrying water, and bones for sewing, among other uses. By about 1700 Spanish conquistadors introduced horses, so eventually the kill sites fell into disuse. However, the basic technique for controlling bison is still used, meaning that if you wanted to move masses of these two-thousand-pound, ill-tempered animals, stampeding would be the way to go.

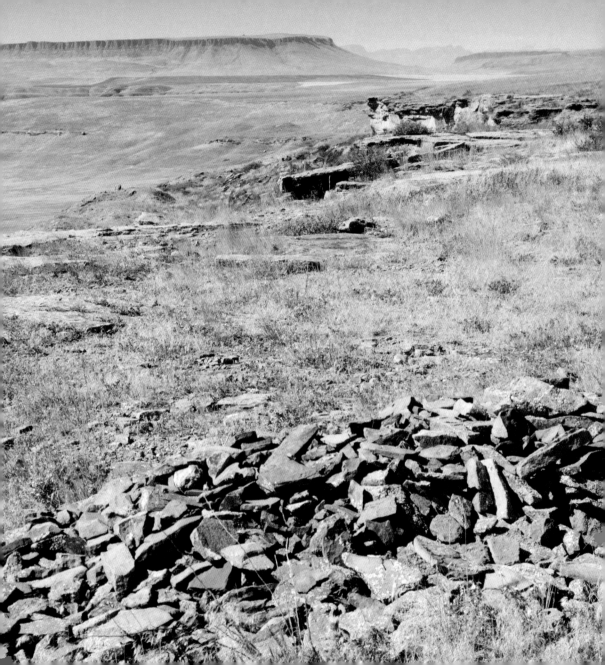

THE HIGHLINE

Rudyard, Montana, is Rip Snorting & Raring for Business, heralds a sign along Highway 2. And then, in a huge red block: RUDYARD, 596 Nice People - 1 Old Sore Head!

So just who is that Old Sore Head?

The billboard is located in a prominent spot along a four-hundred-mile section between Glacier National Park and North Dakota known as the Highline. In this land of extremes, chinook winds frequently supercharge temperatures, creating changes of seventy-plus degrees in the course of a few hours.

Folks who live along the Highline are tough and determined, and most are descended from those who heard the call of the early 1900s Homestead Act. In 1935 Rudyard resident Cliff Ulmen said his father gave him a choice: "You can go to high school, and I'll lose the farm. Or you can help me."

Today, grain and 4-H clubs dominate the proud settlements, though merchants encourage travelers to stop, often by parading history and noting current attractions. On July 4, 1923, Shelby hosted a championship prizefight between Tommy Gibbons and Jack

Travelers along Montana's Highline experience a slice of almost forgotten rural America as they pass through the farming communities of Malta, Havre, Chinook, and Wolf Point.

Dempsey, which the "Manassa Mauler" won. East along the Highline, Cardwell recalls the birthplace of noted newsman Chet Huntley. And near Wolf Point, Louis Toavs has assembled the world's largest collection of John Deere Tractors. But throughout, museums, town theaters, and rodeos abound.

Despite today's attractions, virtually every one of the Highline's humble towns began in the late 1800s when railroad magnate John Hill established his rail lines. Rumor has it that the towns of Kremlin, Havre, Shelby, Dunkirk, Malta, Hingham, Chester, Glasgow, and others were named by a railroad employee tossing darts at a map of Europe. And then there is Rudyard, named for Rudyard Kipling . . .

So who is that Old Sore Head?

"Ole Sore Head," said Ulmen, who helps oversee the town's museum, "was the first of the egg-laying dinosaurs, and it died almost sixty million years ago. So we don't have any more sore heads. Just hard heads," he amends with a smile.

In this land of extremes known as the Highline, hard-headed determination is precisely what the land must spawn.

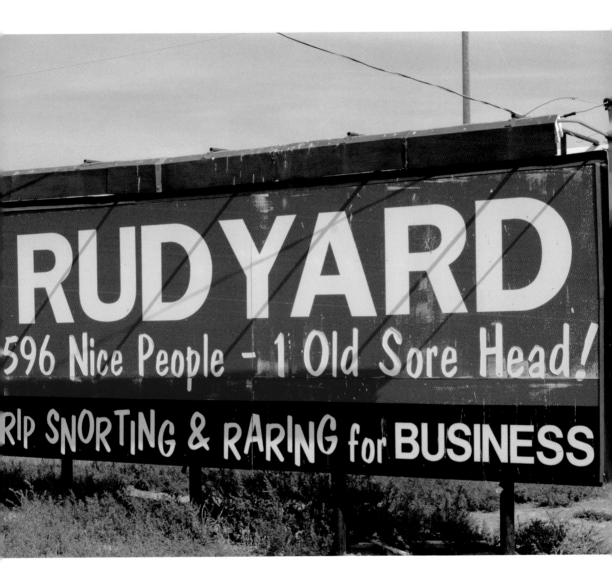

UNDERGROUND HAVRE

When travelers driving Highway 2 pass through Havre, Montana, most are unaware that they are driving over tunnels that once connected an outlawed way of life. Beneath the highway slumbers Underground Havre, a several-block series of rooms that once were opium dens, a bootlegger bar, a gambling hall, a mortuary, a brothel, and a few other businesses that operated in the middle of this Montana town.

Interested visitors must join a guided tour, which begins by descending a series of old concrete stairs. Here, beneath a dusty, hard-glassed skylight, the tour begins, passing first through an old tunnel to a series of clean, well-lighted rooms.

In the former brothel, a mannequin of a come-hither lady symbolizes services that once flourished, and it does the job well. The lady is pressed against a bed covered with a purple quilt, which was folded back—as though extending an invitation. Entrance to her room is through a laced door, and though we heard one woman say, "How sad," I had

For more on Havre Beneath the Streets and the underground tour, check out the site http://russell.visitmt.com/listings/9512.htm.

to question why. Men outnumbered women almost one hundred to one in the late 1800s, and these women softened a harsh landscape in which hostilities were but a quirky gesture away.

Adjacent to the bordello was a bar, but what intrigued many was the mannequin of a man who was prostrate and cradling a pipe. His eyes seemed glazed, and his expression was vacant.

The tour passes through yet other rooms, finally entering an office inhabited by the replica of a small man, but one who enjoyed a huge business. His name was Chris Young, and he prospered in the bootlegging industry, which was big in Havre in the 1920s and '30s. Interestingly, when Young died in 1944 he specified that his fortune be used to benefit children.

One could say that there are lessons here, but most likely they are all of an existential nature. That may not be what the city fathers intended. Most likely they intended to show a way of life that once thrived, and to that extent they have succeeded admirably.

FERRYBOAT OPERATORS

Life along the Missouri River doesn't change too much for the three ferryboat operators that still provide service from one bank to another, and as a result stories live on. A few years ago a man and a woman in a canoe tried to dock upstream. "What they don't realize," said Don Sorensen, owner of the Virgelle Mercantile and one of the operators of the Virgelle ferry, "is that the current flowing beneath the ferry increases to about ten to twelve miles an hour."

Sorensen recalled that the man managed to scramble aboard the ferry, but that the woman and the canoe were sucked toward it. Other canoeists saved the woman when they scrambled aboard the ferry, catching her before she completely disappeared. But the canoe went under the ferry, then shot out the other side like a bullet.

"The canoe was OK," recalled Sorensen, "and so was the girl. But the water pressure had peeled the skin off her belly. And she was terrified!"

For ferryboat operators, no year is ever the same, and each year brings

Ferries are accessed from remote roads. Check detailed Montana maps for specific locations, which include the Carter ferry, Virgelle ferry, and Stafford-McClelland ferry.

some unanticipated event that explains why the county posts signs advising passengers that they must assume risk for any accidents that may occur. In 1983 a young fellow drove a truck load of barley onto a Montana ferry and failed to set the hand brake. When the ferry began to move the truck rolled off the end of the ferry and sank into about seven feet of water. Luckily a tractor pulled out the truck. The grain was lost, but the truck still functioned.

The season for Montana's ferryboats begins about March 15 and runs until about mid-November. Most operators are on call twenty-four hours a day, and it's not uncommon for one to have to rise from bed at three o'clock in the morning. "What happens," says Beverly Terry, another operator of the Virgelle Ferry, "is that ranchers want a break, and go into town, not returning 'till the wee hours of the morning."

The busiest operator may be the Loma Ferry operator, putting in more than 80 hours a week or about 360 hours a month. In a typical year he'll make over 7,200 crossings.

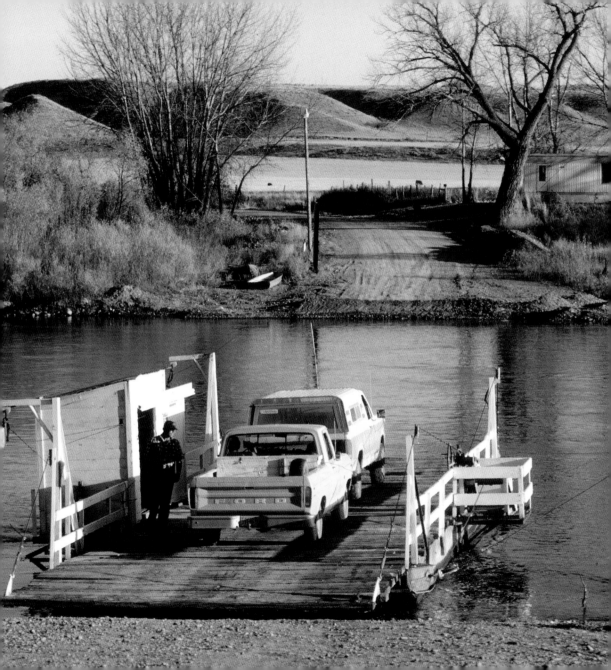

FLIGHT OF THE SNOW GOOSE

Out on a prairie lake throngs of white birds with charcoal-colored wing tips are creating a clamor that sounds like a distant crowd cheering for a star performer. When the noise is the loudest the birds rise from the pond as though endowed with a single mind.

What's so absorbing besides their "cheers" and astounding numbers is the way in which each individual bird fits into something so much larger than itself. In unison the flocks swell, swirling like tornados, swooping and rising, then finally settling. Amazingly, individual birds never collide; indeed, they never even touch, despite the hair's-breadth-close formations.

On average, snow geese remain "4.2 days" at Freezeout Lake before their group is ready to move north. Their journey poses an intriguing question: Why migrate a distance that can exceed two thousand miles each way when some of their close cousins are content to remain within several hundred miles of their place of origin? Though no one knows for sure, perhaps snow geese discovered a food

For more information on this area, visit www.crownof thecontinent .net and search for Freezeout Lake Wildlife Management Area.

base during the ice ages, and they began to move northward as the great glaciers began to recede.

Whatever the reason, the birds are compelled to move, and one day a segment of the flock lifts from the lakes into the air with apparent resolve. Strong winds have been forecast, and perhaps the geese sense it. Higher they fly, spreading out into a number of loose but quite discernible V formations. Set against the cerulean sky, flocks of *Chen caerulescens* strike out for the Arctic. Six months later, about Halloween, flocks return to Freezeout, the paired-for-life adults bringing with them whatever number of young from an average clutch of four that has survived. Then, it's on to Thule Lake in California.

Yet another six months and the cycle repeats itself, with still-intact family groups flying north. Once again, they've returned to replenish their supply of fat and strength along Montana's Rocky Mountain Front. It's the way of many snow geese in the Pacific Flyway, a constant that may date back to the last great ice age.

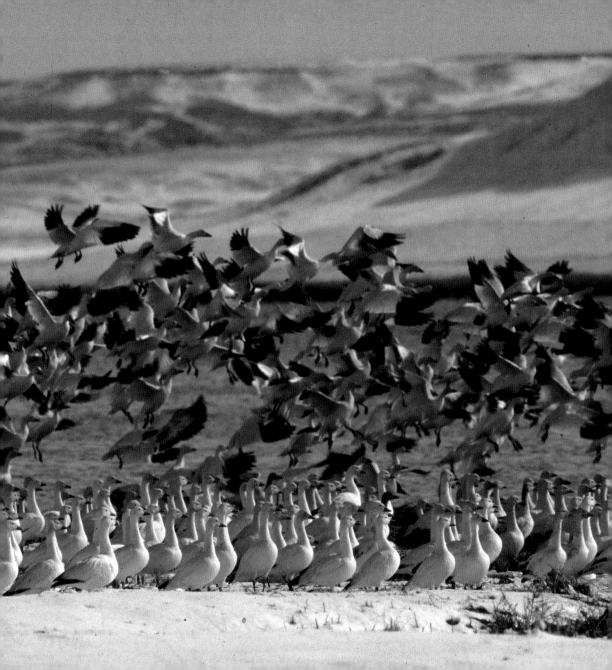

BEAVER SLIDES

The horses were all beautifully matched pairs and well trained for the job at the Grant-Kohrs Historic Ranch in Deer Lodge, Montana.

"Raise your foot," said one of the team drivers in a quiet way, reminiscent of the protagonist in the movie, *The Horse Whisperer.* "Step left."

The job at hand was a multitasked one and the horses responded on cue. Horses and the team driver were collecting hay previously pushed into windrows. Now horse managers were directing the teams to push it again, to ultimately assemble a stack that would look like a huge loaf of bread. Facilitating the job was an old-time farming implement locally known as "the beaver slide."

Horses, of course, perform much of the work, moving hay from the windrows with a buck rake to the base of a beaver basket. Cables are attached to the basket and then strung out to the harnesses of another set of powerful horses. On command, the pair moves forward and the beaver basket begins to rise. When it reaches the top, the hay flips out and

The Grant-Kohrs Ranch National Historic Site (www.nps.gov/ grko/index.htm) preserves the art of creating beaver slides, an agricultural work of art.

into a growing pile. Draft-horse power and synchronicity are all on stage.

Haying with beaver slides at the Grant-Kohrs Ranch is conducted in part to help preserve history. But it is still used in the southwestern part of Montana, in part because it is economical.

Jay Nelson of Montana's Big Hole Valley remembers well the importance of the beaver slide. Right after World War II he built almost forty of them and says they were invented locally about 1909.

Though many ranchers in Big Hole country still use the beaver slides, such implements are being replaced by the mechanized "round bailer." Jay laments their passage, wishing for the days when the Big Hole Valley was famous for its reputation as the "Valley of Ten Thousand Haystacks." Though the use of the more labor-intensive beaver slides is diminishing, Grant-Kohrs intends to preserve the art for the foreseeable future, and will continue with its summer demonstrations. "Who knows," Jay speculates, "when horse power will again be more efficient than gas power?"

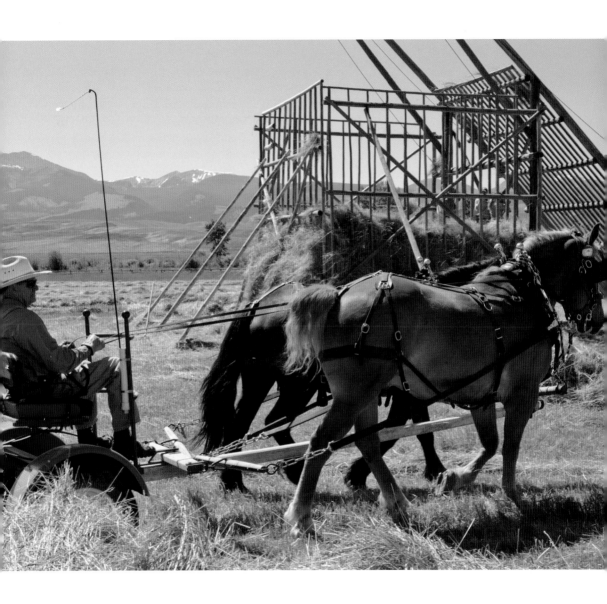

DEER LODGE PRISON

Is life little more than a crapshoot? That's the question some pose while touring the old prison in Deer Lodge, Montana. That facility—now replaced by a nearby more modern facility—once handled some of the nation's most incorrigible criminals.

Jerry Myles was one such man, and his résumé at the time of incarceration in the Deer Lodge Prison included stints in prisons in Georgia, Illinois, and Alcatraz. He committed at least fifteen crimes in eight states, including burglary, grand larceny, conspiracy to commit robbery, mutiny with weapons, and finally threats to burn captured guards alive. Myles absolutely despised authority, and he hated women. Prison physiologists say Myles also had an IQ of 125, suggesting that environmental circumstances were just too much for him to overcome, bright though he may have been.

Jerry is best known for the lead role he and Lee Smart, his young male "wife," played in the infamous prison riot they started in 1959 at Deer Lodge. Because contemporary prison conditions were so horrendous, they found a willing following among other inmates.

If you want to tour the prison, read up on its history, or even find a link to buy items from the gift shop, visit www.pcmaf.org/shop.

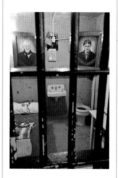

The riot lasted several days and included the shooting of a deputy warden and the suicide-murder of Myles and Smart. It ended when men from the Montana National Guard stormed the old prison, first firing a bazooka into Cell Tower One, where Myles and Smart had been controlling rioting prisoners. That hole still exists and serves to remind us of the days when things went so awry.

In part because of the riot, Montana built a new prison, more modern both in structure and administration. Prisoners may now have access to activities that channel emotions and encourage self-examination. Today convicts are encouraged to improve skills in the trades, advance themselves academically—or express themselves artistically. Many do, and their works are for sale in a store near the old prison.

Art may enable some to work out the frustrations of lonely childhoods, fraught in some cases with much pain and abuse. It provides opportunities for introspection and perhaps a way to deal with the horrendous circumstances into which chance birth once placed them.

BUTTE, AMERICA

"To gain entry," said Denny Dutton of Old Butte's Historical Adventures, "first we had to break a lock. Then we had to kick down the door. What we found," continued Dutton, "was an old speakeasy buried beneath the sidewalk—idle for over sixty years."

Dutton and Mike Byrnes, his business partner, made this find in July 2004, and with that discovery and the development of other historic structures, "Butte, America," as it was famously called in the 2009 documentary, is continuing to cash in on its legacy of grand history, which includes many firsts, as well as some flirtations with the sordid.

"Butte," says Dutton, "was the first American town to be electrified, and it once had the nation's most diverse ethnic population. Because of the manganese and copper used for making tracer rounds, it helped win World War I and World War II. And, of course, it was once the largest mining town in the world." Here, because miners often worked for meager wages, unions sprang up, and some leaders became martyrs.

This once-booming mining town has even more historical charm aboveground than below. For information on attractions and year-round events, visit www.buttecvb.com.

In July 1917 Frank Little, a leader of the Industrial Workers of the World (IWW), preached rebellion. One month later six men pulled Little from his boarding house, dragged him behind a car and then hung him from a railroad trestle with a warning sign aimed at strike leaders. Admirers, however, still leave charitable notes at his gravesite, often accompanied by a bottle or two of Irish whiskey.

Butte is also known for the infamous Berkley Pit, its well-preserved old brothels, and the old Finlen Hotel. Hotel guests have included John F. Kennedy, Robert Kennedy, Harry Truman, Richard Nixon, and Charles Lindbergh. Many of Butte's famous spots have been restored, and if you step into the Rookwood Speakeasy, you can feel the 1920s ambience. Suddenly you're back there, with cigarette smoke and the sounds of jazz wafting through the air while dapper Dans are partying the night away.

Really, not too much has changed in Butte, America.

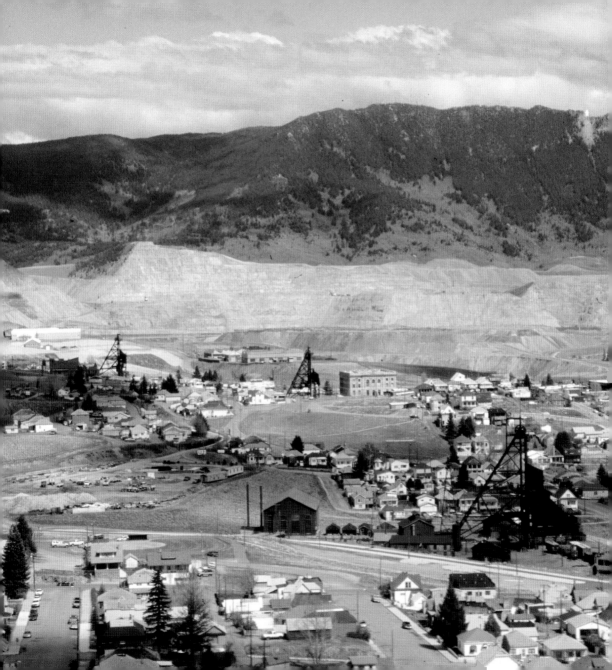

MANSIONS OF THE WEST

Historic homes linger in a number of Montana towns, but three of these mansions owe their charm to two men who were just as flamboyant as their opulent dwellings.

Marcus Daly, the first of our rags-to-riches adventurers, was born in Ireland in 1843, and his exodus takes on the drama of a character from a Louis L'Amour western novel. Arriving broke in New York when he was only fifteen, he likely fought for most everything. When he was twenty, Daly bought passage to San Francisco, where he became a successful miner. But this hard-working man was also lucky: Mr. Walker, owner of a banking syndicate, was inspecting a Salt Lake City mine with his daughter, Margaret, who lost her balance and tumbled into Daly's arms.

Several months later they married, and Mr. Walker sent the couple to Montana to invest in a silver mine. Daly became part owner but soon sold his share to reinvest in his own silver claim. Silver was profitable all right, but his crew hit a copper vein and the timing could not have been better. The nation

These magnificent homes are reminders of the millions (and millionaires) made during the height of Montana's gold and copper strikes.

needed copper to help power Thomas Edison's newly invented light bulbs. For Daly, wealth became his to command and enjoy, and he naturally built several showcase homes in Montana, one in Butte, another in Hamilton.

Charles Conrad had similar larger-than-life beginnings. During the Civil War he fought with Mosby's Rangers of the Confederate Army, but when the war ended, the South was impoverished, so the young man headed west. In 1869 he drifted into Fort Benton where he found favor with the very successful I.G. Baker Mercantile Company, which the enterprising young Conrad soon bought.

Conrad moved to the Flathead Valley, founded the city of Kalispell, established the historic Conrad buffalo herd (whose descendants now roam the National Bison Range) and built his much admired Conrad Mansion, now on the National Register of Historic Places. The Conrads entertained the rich and famous, including Theodore Roosevelt. Today, Montana history comes alive through the legacy of these opulent homes.

BANNACK'S VIGILANTES

Bannack, Montana, the state's first territorial capital, was founded on July 28, 1862, but the old ghost town looks about the same as it did during its heyday. Old wagons stand ready to transport gold, buildings appear inhabitable, and the old jail—Montana's first—appears ready to accommodate thieves, drunks, and murderers. And, on the hill in plain sight is the place from which many a man took "the long drop." Most were deserving, but there is speculation about the hanging of one man.

The man's name was Henry Plummer, and he arrived in Bannack in 1863. Glib and persuasive, he was soon elected sheriff. What was not known by the town's citizens is that Plummer was most likely the leader of an outlaw gang. Before long, road agents began targeting the road between Bannack and Virginia City–the Vigilante Trail–for unwary miners.

Through a brief period of but several years, they killed or robbed over one hundred travelers. To combat the road agents, a group of Bannack men formed a vigilante committee. Working under-

For directions and more information on this National Historic Landmark and the site of Montana's first major gold discovery on July 28, 1862, visit http://stateparks .mt.gov/parks/ visit/bannack.

cover, they soon had a list of suspects. Before long, they were painting the thresholds of a suspect's cabin in blood or in red paint with the numbers "3 + 7 + 7 + 7." The message was that the individual had twenty-four hours in which to leave town—or else!

Not all heeded the warning, and one man about to be hanged pointed a finger at Henry Plummer. Though not immediately convinced, the vigilantes regrouped. For several weeks they meditated heavily. Then, fortified with an abundance of liquor, they concluded Plummer was guilty after all.

On January 10, 1864, about seventy-five men marched Plummer to the gallows. Though Plummer begged, pleaded, and even offered to tell where $100,000 in gold was buried, the group ignored him. "Just give me a good drop," said Plummer to the hangman.

The vigilantes accommodated him. But was Plummer really guilty? Today, historians aren't so sure. In fact, one local historian believes the vigilantes may have been trying to divert the blame from the true robbers: themselves.

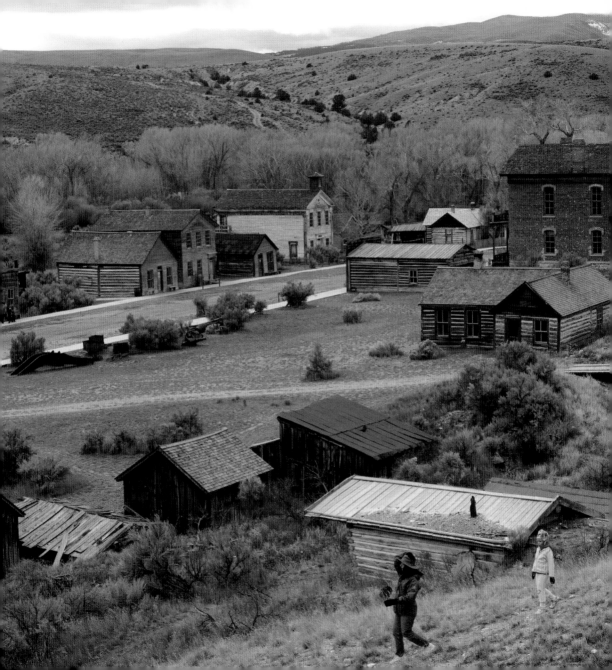

BIG HOLE RIVER

They're only about three inches in length, and they appear along the Big Hole River but for a few brief weeks year. But when they do appear—usually about the second week of June—they create an uproar among anglers.

The tiny creature responsible for this fanaticism is the salmon fly, and when it emerges, trout go "crazy mad," and anglers go crazy mad in chase of them. The creature's cyclic nature, however, can be slow, for it is a finely tuned biological phenomenon.

Females deposit eggs atop the river's rushing waters. The eggs then drift to the river's bottom, where the nymph stage begins to develop. Three years later, mature nymphs head toward the river's banks and then crawl up onto shoreline vegetation where they struggle to break free of their "shuck." They crashland onto the water's surface, and when they do, fish go insane.

About this time anglers flock to the 188-mile-long river and cast their bait.

Dillon is one of several towns near the Big Hole that attracts anglers.

Like clockwork they begin reeling in the trout, and sometimes their catches produce results that exceed all expectations, even those of your guide.

I watched as Chuck Robbins made a few tentative casts, landing several medium-size fish. He cast again, and this time his rod arched sharply. He knew what he was doing and played the fish slowly, bending his body left, then right, keeping his line tight all the while. He knew exactly what he had hooked.

Chuck said it was the largest brook trout he had ever caught in Montana, believing it was too beautiful to keep. He released it, and we watched as the lunker regrouped and then—with a sudden flick of its tail—reentered the swift waters of the Big Hole. This heroic river is set in timeless mountains—a place where the salmon fly is as famous as the noble fish that follows it.

"Someday," said Chuck with satisfaction akin to an evangelist, "we might just catch that ole brookie again."

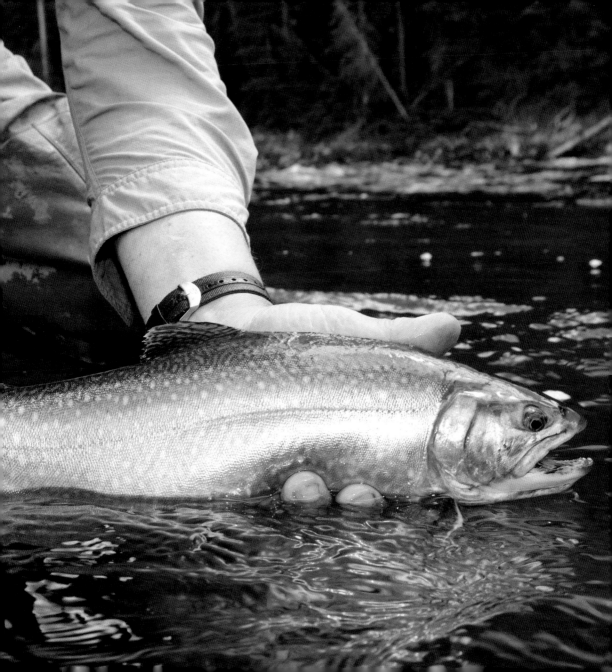

CHIEF JOSEPH

In a field of purple camas, feathery pink prairie smoke and white bistort, naked tipi poles stand today like skeletons reminiscent of a great tragedy. At night, when stars shine and twinkle through the frames with their look of beneficence, you can almost hear the Nez Percé asking the Great Spirit why he stopped smiling.

The skeletons remind the sympathetic that on a predawn morning in August of 1887, soldiers fired into a sleeping camp of Nez Percé Indians at what is now the Big Hole Battlefield. They sought freedom and did not want to be forced onto a reservation in Idaho. They had, after all, successfully negotiated for the land of their fathers. But the very same land was coveted by gold seekers.

Immediately after the initial attack, the Nez Percé sought cover, running into willow thickets, even submerging themselves in the river, but Chief White Bird's voice carried over the screams of horror, rifle fire, and even canon fire. "Why are we retreating?" he shouted.

And so began an incredible turn-

This epic struggle is chronicled at the Bighole Battlefield (www.nps.gov/biho/index.htm) and the Bear Paw Battlefield (www.nps.gov/nepe/planyourvisit/bear-paw-battlefield.htm).

about. Before long, soldiers fell, and the tide turned, allowing chiefs Joseph, Looking Glass, and White Bird to continue their 1,500-mile hegira through Yellowstone, across the Missouri River and almost to Canada, where they had been offered freedom.

By the time fall had arrived, attrition had taken its toll. Though the Nez Percé had out-generalled the soldiers at virtually every encounter, ultimately they could not compete with their firepower.

In the Bear Paws, soldiers fired their Hotchkiss gun, immediately killing two women. Chief Joseph was moved to compassion, and on the afternoon of October 5, 1877, he asked to surrender. Joseph handed his rifle to General Miles and began a speech that is now famous. He described the condition of the children, saying that they were cold and starving. He confessed that his heart was sick and sad, declaring that from "where the sun now stands, I will fight no more forever."

Despite mistreatment, he stayed true to his word, and today history recalls him as a great statesman.

MONTANA'S NATURAL HOT SPRINGS

"Cold smoke" is a term used by mountaineers to describe fluffy snow that steams from ski bottoms when skiers bear down to force an exhilarating turn. When deep and loose, cold smoke can be difficult to navigate, resulting in bruised hips, twisted ankles, and strained lumbar muscles. The situation calls for relief, something soothing enough to drive away those aches and pains. Montana's many natural hot springs are the perfect antidote, melting away knotted muscles like the best massage therapy.

Geological forces, of course, created these glorious springs. Millions of years ago, when tectonic plates collided, the earth buckled upward, creating lofty peaks. Sometimes, the collision of the plates also left deep clefts. Gravity has drawn water down through these openings where it is superheated and then forced back up, resulting in our present-day hot springs.

Literally dozens of attractive thermal springs are located throughout the state, and one is found in the northwestern part of Montana in the appropriately named remote village of Hot Springs. Sample these waters from your base at

Montana's hot spots are numerous and range from forested hiking destinations to resorts that pump the warm springwaters into hotel pools.

the Symes Hotel, but don't leave this funky little town before trying a plunge in a private cubicle (suits optional) at the nearby Wild Horse Hot Springs.

Most hot springs are associated with the state's mountainous regions. Chico Hot Springs is nestled in the shadow of northern Yellowstone, the park noted for its thermal features. If you're looking for posh accommodations, this resort in central Montana has them.

For sheer quantity, southwest Montana has the greatest number of hot-water springs, claiming over twenty. Some are little more than mineralized flows steaming into cow pastures flanked by the Bitterroot, Pioneer, and Sapphire Mountains. But most are associated with ski areas, such as Lost Trail. Here waters pour out of the mountains at around 130°F. Like some of the other springs, this one is remote, and on clear, cold nights Lost Trail is characterized by brilliant starlight, which often reflects off all that freshly fallen "cold smoke." Happily, the surrealistic wintry scene is associated with steamy springs, a combination that can approach the sublime.

GARNET GHOST TOWN

Outside our small cabin, wind-blown pines scraped together, creating a wailing sound that at first resembled the screeching of a catamount, then the tired voices of ghosts. Janie added a log to our woodstove, while I, seated at a nearby table, added a dollop of brandy to the coffee and began dealing cards. Surely any ghosts drifting along the snow-laden paths that coursed between the thirty-some clapboard buildings would understand my momentary weakness, for at one time the small town in which we were staying had boasted nineteen saloons. Today, the town is deserted, its one thousand former residents having either been killed, died naturally, or simply moved on.

Garnet might have gone the way of many other ghost towns but for the cooperative effort of the Bureau of Land Management and the Garnet Preservation Association (GPA) to restore the once-eroding buildings. Today Garnet is considered to be Montana's best-preserved ghost town. Indeed, as we skied through the town and out to its periphery we had a feeling the town had been only recently abandoned. Curtains

For historic details and information on winter cabin rentals (maybe even cabins with ghosts), go to www.garnet ghosttown.net.

still hung in many cabins, and we peered hard to assure ourselves that no one was peering back.

We had arrived in Garnet earlier that January day after skiing four miles up a steep snow-packed road south of Missoula known as the China Grade. We skied down the town's main street, quickly finding the Dahl Cabin, all furnished except for sleeping bags.

Next morning we skied from the rental cabin and glided down the long slope to the town's edge. We wondered about the town's residents and those who discovered gold in nearby Bear Creek. Story has it that they removed over eight million dollars in precious metal.

Late that afternoon, snow began falling, and we returned to our cabin and rekindled the fire. Predictably, trees began to moan, sounding once again like muted voices. Dealing out the cards, and refortifying our coffee, we settled back to listen to the muffled exclamations of excited miners, blustery shouts from Ole's Tavern and raucous laughter of the hurdy-gurdy girls . . .

My, how ghosts can wail on a wintry night in Garnet.

SLEAZY SALOONS

In 1970 beat poet Jack Kerouac visited the M&M Bar in Butte, Montana, and was so inspired by the assortment of characters that he included impressions in his book, *On The Road:*

"What characters in there: old prospectors, gamblers, whores, miners, Indians, cowboys, tobacco-chewing businessmen . . . It was the end of my quest for an ideal bar . . ."

For over a century the M&M was Montana's longest operating bar. Sadly, that run ended about the year 2000. But don't despair—it has reopened. But even without that venerable institution, Montana has great depth. A lonely traveler has other options.

According to Gloria, the owner of the Dirty Shame, her business rose to prominence in 1970, when a group there almost hanged a man with the unfortunate name of Tom Dooley—although a century had passed since the conviction and hanging of the infamous murderer Tom Dooley.

Though "decorum" remains, there is cause for continued reclassification as recent clients have included movie actors and actresses. Does the Dirty Shame

Forget every preconception you may have about saloons of the Wild West. These Montana watering holes are full of unique surprises.

have too much class?

The Sip & Dip in Great Falls rates high. The interior of the bar is graced with a huge window and on weekend nights, live "mermaids" swim behind a glass wall, just inches away from patrons. The glamorous outfits are comprised of a bikini top and a matching tapered skirt that ends in fins, resembling the lower extremities of an actual mermaid. The mermaids' movements are sensuous, and biblical scholars drinking their whiskey neat with beer chasers at the nearby bar will be reminded of Salome and her dance of the seven veils.

Of course there are many other contenders, such as Katie's Wild Life Sanctuary near Bynum, the Jersey Lilly near Ingomar, Belt (boasting strong drinks) in Belt, and the Windbag (a former bordello) in Helena. The list goes on, but because we can no longer rely on Jack Kerouac for guidance (he died October 21, 1969), we must rely on others to help define what qualifies as a Montana sleazy saloon. Readers might want to conduct their own research, realizing of course, that certain standards must be maintained.

NATIONAL BISON RANGE

High atop a windswept butte at the National Bison Range in northwestern Montana, two giant bull buffalo backed ponderously away from one another until they stood twenty feet apart. The mammoth beasts pawed angrily at the parched grass, kicking dust high into the air, roaring like lions.

Muscles tensed; then the animals bore down on one another, crashing with such momentum that the sound of their impact carried far above the gusting wind of the sprawling plains. Again and again they repeated the ritual, colliding like locomotives. Finally, just as the sun dipped toward the distant jagged peaks of the snow-covered Mission Mountains, one combatant turned groggily and staggered off. With eyes aglare, the other turned, searching for yet another challenger. Clearly, this huge bull was king of the pasture.

One hundred years ago this spectacle was as endangered as was the species essential to the contest. Its existence is part of an epic narration and dates back to the spring of 1873 when Walking Coyote, a member of the Pend d'Oreille

For National Bison Range hours and special events, as well as links to related resources, check out www.fws.gov/bisonrange/nbr.

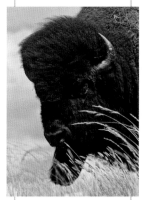

tribe, captured five buffalo calves from one of the nation's last great herds.

The following spring Walking Coyote took the young to the Flathead Indian Reservation adjacent to today's refuge. The calves were unusually tame and soon became favored pets. The nucleus herd expanded and by 1884 numbered thirty. Eventually, the American Bison Society bought a portion of the still-growing herd (augmented with some from Yellowstone National Park), and on October 17, 1909, thirty-four bison from the original Walking Coyote herd were released onto the 18,540-acre refuge. Today, descendants of those animals compose not only one of the world's largest and best-managed herds, but are manifest as well in other national herds. Throughout, they remain vigorous, combative, and genetically capable of expanding back into the West should the need ever again exist.

In the meantime, hundreds do at times thunder across strategic expanses of the state's magnificent grasslands, exhibiting a sustained prowess as they await their day back in the sun.

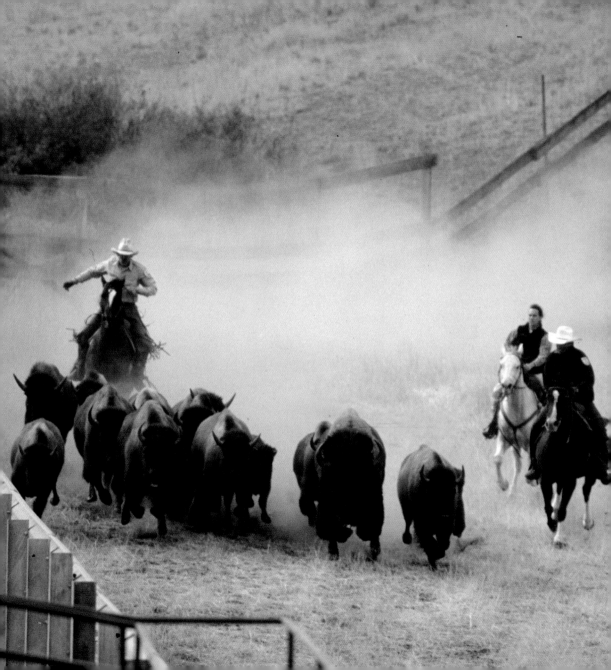

WILD HORSE ISLAND

Typically the first week or two of May is the perfect time to see the vast fields of arrowleaf balsamroot running from hill to hill on Wild Horse Island. This swath of silvery green and bright yellow is surrounded by Flathead Lake, the United States' largest body of fresh water west of the Mississippi River. To the north are the ranges forming Glacier National Park while to the west are the Salish Mountains. And at your feet are sweeps of gold-colored balsamroot, making it difficult to imagine a more magical setting than this island retreat.

Legend has it that Wild Horse derived its name from a time when the Salish-Kootenai Indians drove their horses into the glacial waters of Flathead Lake and then swam them to the island, where they were safe from raids of opposing tribes. But the 2,156-acre island provided such a secure hiding place for the half-tamed horses that many were overlooked when time came to retrieve them. Those animals soon reverted to their natural wild state.

Though there are other access points for both departure and landing, the shortest route to Wild Horse

Unless you own a boat, access is a challenge. For commercial tours check out www.wild horseislandboat trips.com.

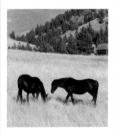

requires a two-mile boat ride from Dayton, Montana, on the lake's east side. The trip can be made by either powerboat or kayak. Once you've docked at Skeeko Bay, you can follow a trail a short distance from the shore to an old homestead cabin. From the cabin, the trail climbs about seven hundred feet, and it is here horses are commonly seen.

The trail climbs on, wandering as it does regardless of season among extensive grasslands, ponderosa pine, and Douglas-fir. Huge deer live here, and because hunting is not permitted on the island, wildlife has become somewhat tolerant of humans.

Bighorn sheep also inhabit the island, and they occupy a historic island niche. To prevent overpopulation, biologists transplanted sheep from Wild Horse, inaugurating new populations. Typically, fifty to sixty sheep occupy the rocky cliffs adjacent to the trail.

From the top, the view is panoramic, progressing from water to mountain peaks. Birds soar overhead, but they lack the grounded perspective enjoyed by hikers: flowers, pageants of wildlife, and the half dozen wild horses.

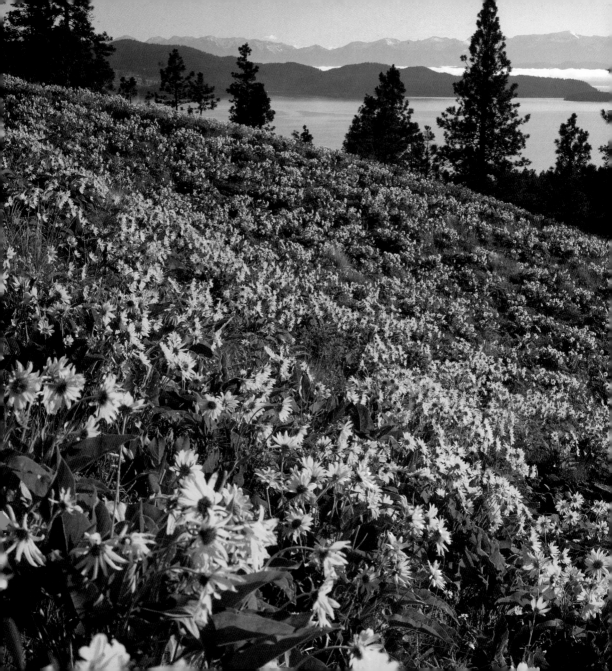

JEWEL BASIN

Sometime in early July dense fields of lush green and white-flowering beargrass carpet the western slope of the Swan Mountains, radiating so much crystalline clarity that they can sometimes be mistaken for vast fields of snow. But we know them for what they are, and when we see them, we know the real snowbanks have mostly receded, and that one of the most stunning hiking areas in the state is now accessible for fair-weather hikers.

At long last, winter in the Jewel Basin Hiking Area has ended and, finally, we can make the ten-mile drive up a winding dirt road to Camp Misery. From here, trails lead to a variety of enchanting destinations, and regardless of which path you choose for your explorations, there will always be something of interest. Wildlife is abundant, and the parade of wildflowers and fall berries lasts till the first snowfall.

Trails into this de facto wilderness lead to an infinite number of gems, such as Twin Lakes and Black Lake. But most often the trail we follow winds its way to Mount Aeneas, the mountain that offers the greatest of views.

Hiking is one attraction, but so is fishing. To find out all this gem offers go to http://visitmt.com and search for Jewel Basin.

Indeed, Mount Aeneas is a lofty peak, accessed by a well-maintained trail. Elaine Synder, a volunteer hike leader with the Montana Wilderness Association, says that the mountain was named for Kootenai chief Big Knife. He was adopted by the Kootenai people in about 1870, and somewhere along the way, his name got changed to Aeneas. (According to some sources, Aeneas is a variation of Ignace, which is the Christian name by which both his father and grandfather were known.)

Snyder also says that Bob Marshall once hiked the area, noting that in late August of 1928 he walked through what is now the contiguous 1,009,356-acre wilderness bearing his name. Marshall then capped his adventure with a climb up Mount Aeneas.

Certainly Aeneas is a jewel, and it is compelling because in an owl-like crank of the neck, one can see Flathead Valley, including the north end of Flathead Lake, as well as the Swan range, the Mission Mountains, the Great Bear Wilderness, and Glacier National Park. Aeneas, however, is just one of many gems in a necklace made of many other jewels.

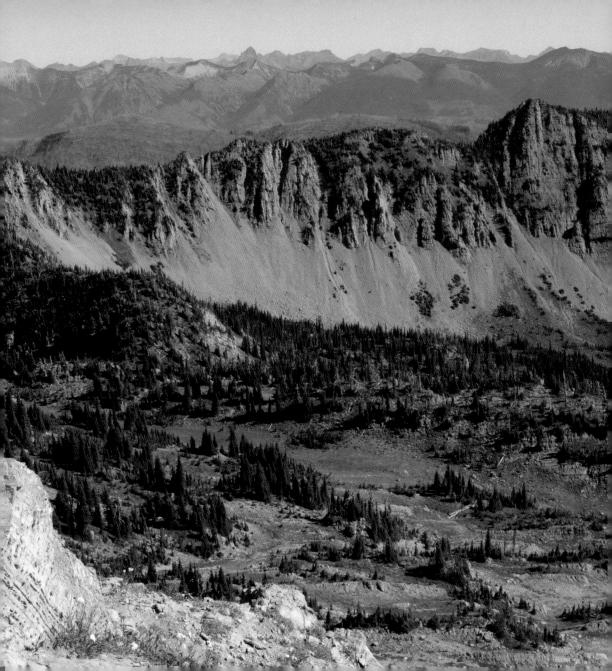

GREAT BEAR WILDERNESS

Just around a bend in the Middle Fork of the Flathead River, a small herd of elk stood dipping their muzzles into a quiet pool. From our vantage the animals appeared as dots, but as we drifted closer the sentinel suddenly squealed an alarm. In unison, the elk wheeled and crashed into the nearby timber. We floated on.

Less than an hour later we encountered a series of turquoise-colored pools that we could not pass by. Hauling the raft ashore we fanned out, fishing gear in hand. Soon rods bent, and the pure and endangered westslope cutthroat pirouetted across the water's surface.

Though we were adrift in a river reverie, we were also aware that the Middle Fork can be vicious, but at the moment we were talking quietly among ourselves, recalling all the benefits the river offered. Challenges were several days and many more bends ahead.

We were floating through a wilderness area that connects Glacier National Park with the Bob Marshall Wilderness. Known as the Great Bear Wilderness—or simply "The Bear"—the land was set aside in the late 1970s, primar-

For more information on adventures in this area, check out http://visitmt .com and search for Great Bear Wilderness Area.

ily to provide the free-ranging grizzly with a continuous corridor needed to enhance its genetic diversity. Certainly the 285,700-acre chunk of land has done this and much more, becoming a prototype of what wilderness should embody.

All good wilderness areas should provide a modicum of adventure, and the Great Bear Wilderness did not disappoint. On the next and last day of our float we arose early. Our waterproof map indicated we were approaching Spruce Park, a stretch that can sometimes produce whitewater in the Class V category. With some degree of bravado, we pushed our whitewater raft into the current and almost immediately were battered by waters that tried to lift us end over end. A forward thrust of our oars corrected us—to then confront the other challenges that were so famous along this quarter mile stretch of water with its much touted forty-one-feet-per mile drop in gradient.

Once again, the river had aroused within me an abiding love for all pristine waters found throughout the state's many wilderness areas.

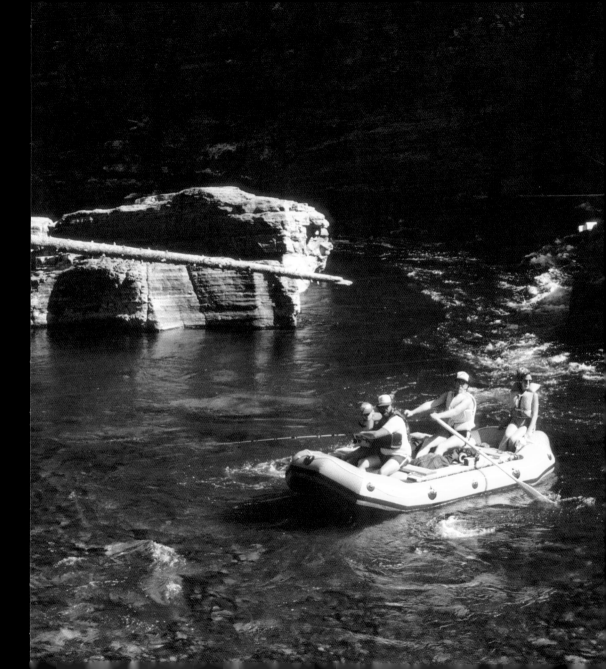

GLACIER NATIONAL PARK

With a hushed whisper, Janie asked me to stand still. "Listen," she said. "What do you hear?" The answer was nothing. Absolutely nothing.

Grandeur spread before us, and though its existence was the result of magnificent motion, nothing stirred. From my years of working in this land known as Glacier National Park, I knew the park was the result of motion that vacillated between calm and an overwhelming cacophony of sounds, for the park we were seeing had been born of fire, quenched by torrential rains, inundated by vast seas, forced upward by uneven surface deposits, and then gouged by continental ice sheets that came and went on at least four different occasions. Magnificent forces all, forces associated with sound. But today, we stood shrouded in quiet, overwhelmed by the brooding silence.

Glacier was designated a national park in 1910, and to trudge through this 1.1-million-acre park would take weeks. The quickest overview comes by driving the Going-to-the-Sun Road. But one particularly rewarding method of exploring the park in early season is by

With its heavy snowfall, Glacier's official opening day can be delayed till well into summer. To time your visit right, keep an eye on www.nps.gov/ glac/index.htm for hours and accessibility.

cycling, and one morning in late May we rode to Many Glacier. The day was perfectly clear and there was absolutely no wind. We began cycling about 7:30, and as the day warmed we could feel the coolness from the four- and five-foot-high snowbanks that still lingered. As we rode, we saw three moose and lots of elk and sheep tracks.

We stopped often to take pictures, and about two hours later we reached Swift Current Lake, and though it was mostly frozen, portions had opened near the shore. Because there was absolutely no wind, reflections were nearly perfect. We ate lunch in the shadow of mountains with names such as Apikuni and Angel Wing. Periodically we could hear booming sounds, and we watched as the melting snow released its heavy loads and then cascaded along the slopes of Grinnell Point. But then, there was nothing, prompting Janie to ask the question that seems to have become a mantra.

"What do you hear?"

Once again, we seem to have found perfection.

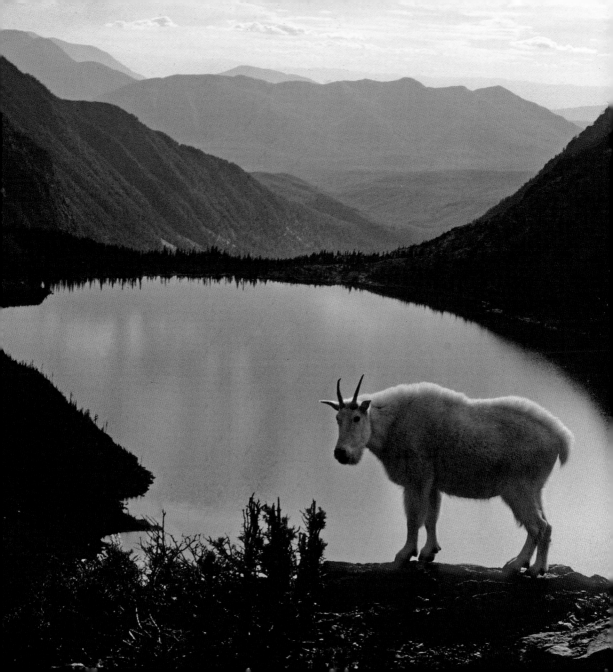

ROSS CREEK CEDAR AREA

Typically, summer days in northwestern Montana's Ross Creek Cedars Scenic Area are sunny, with blue skies offering a stunning complement to the snow-capped mountains of the Cabinet Mountain Wilderness Area. But trails coursing through the understory reflect contrasting conditions. The ground is typically soggy with nearby Ross Creek rushing by and often escaping its banks. Water-loving and shade-tolerant plants carpet the area, including eyecatching species known as Pine Drops, Hookers Fairy Bells, and Queen Cup Bead Lily.

But it is the overstory here that dominates attention. The immense trees are cedars, relative giants whose growth is confined to only a few areas in a state so dominated by prairies and their assemblages of pine, fir, and spruce. Interpretive signs say some of the cedars date back five hundred years and tower 175 feet. Some may measure over eight feet in diameter, making them a logger's dream.

Ironically, local loggers helped bring about the designation of the Ross Creek Cedar Scenic Area. During the

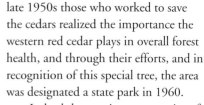

Though this area is remote, access is relatively easy, particularly from Troy. See www.libbymt.com/areaattractions/rosscreekcedars.htm for maps, directions, and more information.

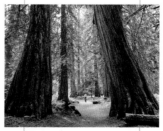

late 1950s those who worked to save the cedars realized the importance the western red cedar plays in overall forest health, and through their efforts, and in recognition of this special tree, the area was designated a state park in 1960.

Indeed the area is representative of unusual conditions for Montana. The nearest town, Troy, boasts an elevation of but 1,880 feet, making it the lowest town in the state. Geographical features also create conditions that funnel in about twenty-five inches of annual precipitation, prompting this area's designation as a "temperate rainforest." As such it has produced these ancient trees that have chronicled nearly five centuries of fire, drought, wind, and flood.

Kootenai Indians tell the story of the "Bad Medicine" campground, which is contiguous with the grove of cedars. In the story, a massive rock ledge broke and covered the area and its occupants. Though Bad Medicine for some, it has been good medicine for contemporary travelers who now enjoy the beauty contained in the Ross Creek Cedar area.

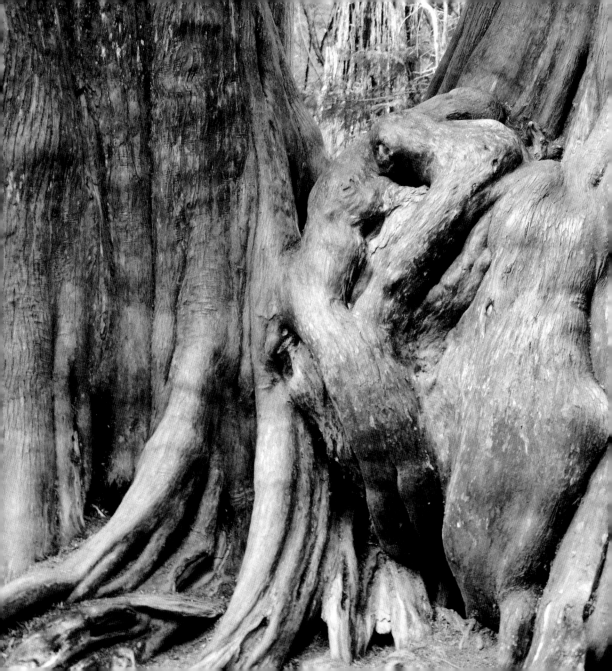

KOOTENAI FALLS

Though Kevin Bacon and Meryl Streep may have navigated Kootenai Falls in the movie *The River Wild,* few others have *successfully* run the rapids. From a point just above the falls the river drops at a rate of ninety feet per mile. Floaters who survive the rapids must then contend with the falls, which drop thirty feet at their most extreme.

Some have attempted to kayak the falls and been successful, but not all.

Early explorers recognized the dangers inherent in the falls and chose to portage. In 1808, the upper end of the falls stopped David Thompson and four other men traveling in a large canoe. It took the men fifteen trips to pack their canoe and all of their equipment around the falls, with each trip taking one and a half hours.

Thirty years later, Father Pierre DeSmet, a Jesuit missionary, arrived at the same conclusion, though his choices were limited as he was progressing up the river rather than traveling down. DeSmet took eight hours to journey around the falls, mentioning in his

To find out more about fishing and other recreational opportunities along the Kootenai, check out www.libbymt.com/ areaattractions/ kootenairiver.htm.

journals that he made the crossing in a quadrupedal position, meaning he was crawling on all fours.

Today, thanks to the establishment of Kootenai Falls County Park in 1991, all aspects of this beautiful cascade can be enjoyed. To look into the mouth of the cataracts, modern-day explorers will have to cross a swinging bridge, and that may be the most challenging aspect of the outing. But the rewards are immense.

Kootenai River flows through a narrow gorge created by ledges of ancient sedimentary rock 1.5 billion years old and dating from the Precambrian era. Once they formed part of a great inland sea and today preserve ancient blue-green stromatolites, still visible as concentric rings.

The falls remain one of the main attractions in the Troy/Libby area, and a challenge to river rafters and kayakers, but you should not be persuaded by the "success" of Kevin Bacon and Meryl Streep. Several have successfully kayaked the falls, but others have made the attempt and met only with tragedy.

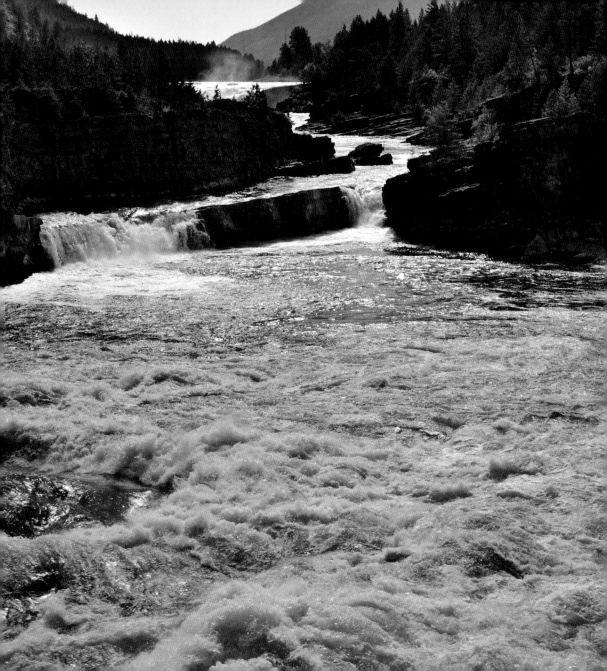

MY HEROES HAVE ALWAYS BEEN COWBOYS

On the walls of an old wooden Montana saloon someone had tacked a poster full of cowboy philosophy. I studied it to the accompaniment of the bar's western music. I guessed the ranch hands that filled the bar that night had most assuredly already pondered the advice contained in the posting, and as I read I heard some echoes.

"Lettin' the cat outta the bag is a whole lot easier than puttin' it back in . . . Good judgment comes from experience, and a lotta that comes from bad judgment."

I knew cowhands who talked like that and recalled the day when my education—and my adulation—began.

At the time, I was working in Glacier National Park as a backcountry ranger, and still can picture trotting my park horse onto a plateau just outside the park near Mad Wolf Mountain. It was here I began matching the country with the characters. As I rode I encountered a huge flock of domestic sheep, then an old sheepherder wagon. Standing by it was a tall, rangy cowboy ranch hand wearing a hat that seemed almost

More cowboy philosophy to ponder: Don't interfere with somethin' that ain't botherin' you none. Timing has a lot to do with the outcome of a rain dance. If you find yourself in a hole, the first thing to do is stop diggin'.

as scarred and weathered as the man. In a gravelly voice he told me to light, that the coffee was always on.

The man's name was Jerry Jacobs, and I soon discovered he was full of the type of earthy philosophy posted on the wall. Though he didn't use all the expressions contained in the posting, nevertheless I associate such wisdom with Montana ranchmen like Jerry. Extractions from the post are profound:

> Your fences need to be horse high, pig tight, and bull strong. Life is simpler when you plow around the stump. Meanness don't jes' happen overnight.
> Do not corner something that you know is meaner than you!
> When you wallow with pigs, expect to get dirty.
> Live simply. Care deeply and love generously. Speak kindly. Remember that silence is sometimes the best answer.

Since ridin' on from Jerry's wagon, I've posted the land-based philosophy on one of my best-lit walls. I read the advice often, and at times I've even tried to apply some of the wisdom contained in those words.

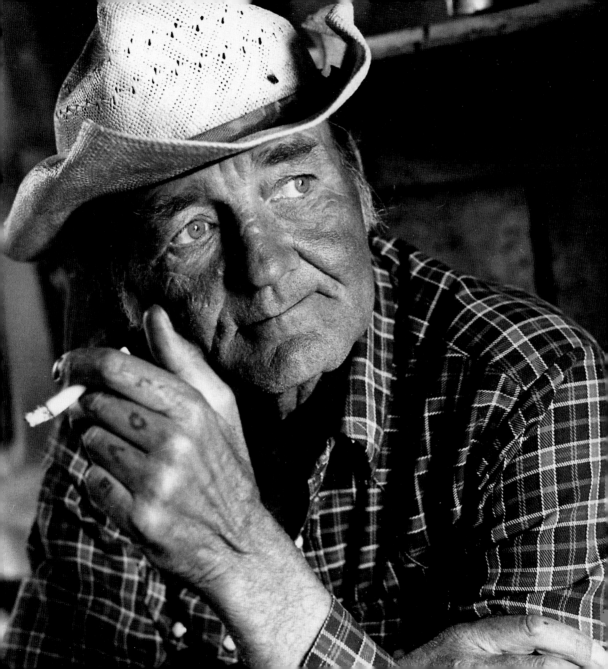

ABOUT THE AUTHOR

Fleeing from the East Coast and strong pressure to follow the family tradition of life in the military, in 1961 Bert Gildart took a Greyhound bus west and landed in the Treasure State. Thirty years later his high school sweetheart followed her heart to Montana, where they married. She has subsequently assisted Bert in his

various pursuits as a journalist and photographer. Their philosophy, "Just take the hand you've been dealt and play it as best you can," has resulted in hundreds of stories and many books, some (naturally) about the state that Gildart says elevated him. Visit him at gildart photo.com.

ACKNOWLEDGMENTS

Though this book is small our appreciation to the many who have helped us learn more about this great state is extensive. Chronologically, Janie and I thank Victor Bjornberg and Donnie Sexton of Montana Tour and Travel who over the years have included us on a great many of the state's "media trips." Though initially Donnie and Victor were only "doing their job," our many visits and discussions about travel in the Big Sky have resulted in sustained friendships.

A special thanks to rangers, country folk, and public relations personnel who invested extra time so that we might better understand what makes their portion of Montana special.

And certainly we want to thank Abbigail Lee at Montana Picture Gallery, who provided a sitting at the Virginia City Studio, intending to create Janie and me in the likeness of our heroes and heroines.

Thanks to copy editors and editors at Globe Pequot, who helped establish a more logical presentation for these essays and have sometimes abided my tendency toward the colloquial. And last, I'd like to thank my good wife who always serves as my first-line editor.